SPORT AND ACTION

KT-431-709

WITHDRAWN

0020521?

Wyggeston QE I

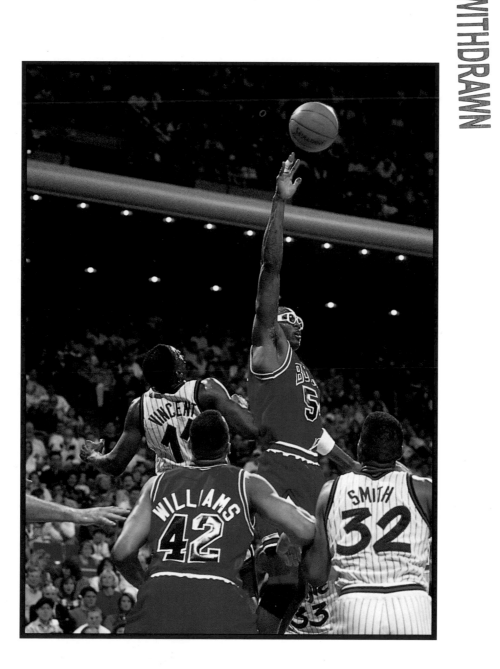

Capturing the moment

CASSELL

ACKNOWLEDGEMENTS

Front cover: (main pic, bottom left, bottom right) Allsport, (bottom
centre) EP/Frank Coppi, 1 ICL, 2-3 Allsport, 4-5 TSI, 5 Allsport, 6
ICL, 7(t) ActionPlus, 7(b) Bob Thomas, 8-9 Allsport, 10(t)
ActionPlus, 10(b) Allsport, 10-11 Allsport, 12, 13(t) Allsport, 13(b),
14(t) Professional Sport, 14(b) Colorsport, 15-30 EP/Frank Coppi,
31-36 Mike Powell/Allsport, 37-40 Frank Coppi, 41(t) Zooom,
41(b) Split Second, 42(t) Allsport, 42(b) Zooom, 43-48 Simon
Bruty/Allsport, 49-50 Allsport, 51-58 EP/Frank Coppi, 59-62 Kos
Evans, 63(l) Allsport, 63(r) ActionPlus, 64(t) Allsport, 64(b) Empics,
65(t) Ardea, 65(c) NHPA, 65(b) Colin Molyneux, 66, 66-7(b)
Allsport, 67(t) TSI, 67(b) Allsport, 68 (t,cr) Kit Houghton, 68(cl) TSI,
68(b) TIB, 69(t) Sporting Pictures, 69(b) TIB, 70(t) Zefa, 70(b)
Sporting Pictures, 71-74 EP/Tim Leighton-Boyce; 75(t) TSI, 75(b)
Allsport, 76(t) Allsport, 76-7 TSI, 77(t) Allsport, 77(b) TIB, 78(t)
Allsport, 78(bl) TIB, 78(br) ActionPlus, 79-82 EP/Frank Coppi, 83-
90 Allsport, 91(t) Allsport, 91(b) ActionPlus, 92 Empics, 93(l) TSI,
93(r) TIB, 94(l) TIB, 94-5 TSI, 95 Chris Nash, 96(t) Collections,
96(b) TSI.

Key: EP - Eaglemoss Publications; ICL - Images Colour Library;
 TIB - The Image Bank; TSI - Tony Stone Images

Consultant editor: Roger Hicks

First published 1994 by Cassell
Villiers House, 41/47 Strand, London WC2N 5JE

Copyright © Cassell 1994
Based on *Camera Wise*
Copyright © Eaglemoss Publications Ltd 1994

All rights reserved. No part of this book may be reproduced or
transmitted in any form or by any means, electronic or mechanical,
including photocopying, recording or any information storage and
retrieval system, without prior permission in writing from the copyright
holder and Publisher.

Distributed in Australia
by Capricorn Link (Australia) Pty Ltd
P. O. Box 665, Lane Cove, NSW 2066

British Library Cataloguing-in-Publication Data
A catalogue record for this book is available from the
British Library

ISBN 0-304-34495-8

Printed in Spain by Cayfosa Industria Grafica

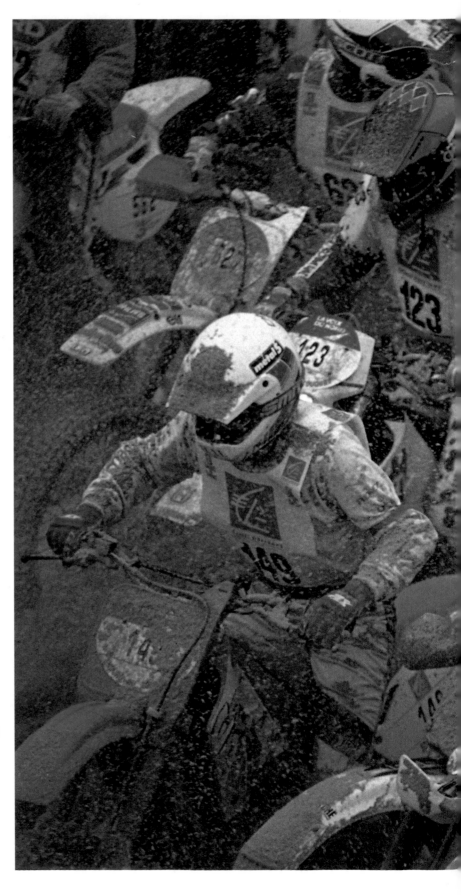

Acc. No.
00205217

Class No. 771
HIC

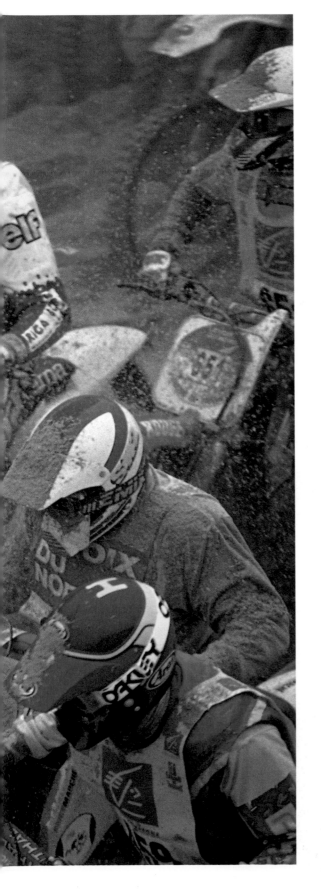

CONTENTS

Sports photography 7-12

Team sports 13-14

Photographing football 15-18

Photographing a rugby match 19-22

Covering a cricket match 23-26

Capturing a school sports day 27-30

Mike Powell – Shooting sports stars 31-36

Frank Coppi – Newsworthy sport 37-40

Motor sports 41-42

Simon Bruty – Capturing the moment 43-48

Indoor sports 49-50

Photographing sport indoors 51-54

Photographing swimming indoors 55-58

Kos Evans – Sport on the water 59-62

Athletics 63-64

Horsing around 65-68

Martial arts 69-70

Photographing skateboarders 71-74

On two wheels 75-78

Shooting cyclocross 79-82

Marathons 83-86

10 tips for better sport and action
 photography 87-92

Dance 93-96

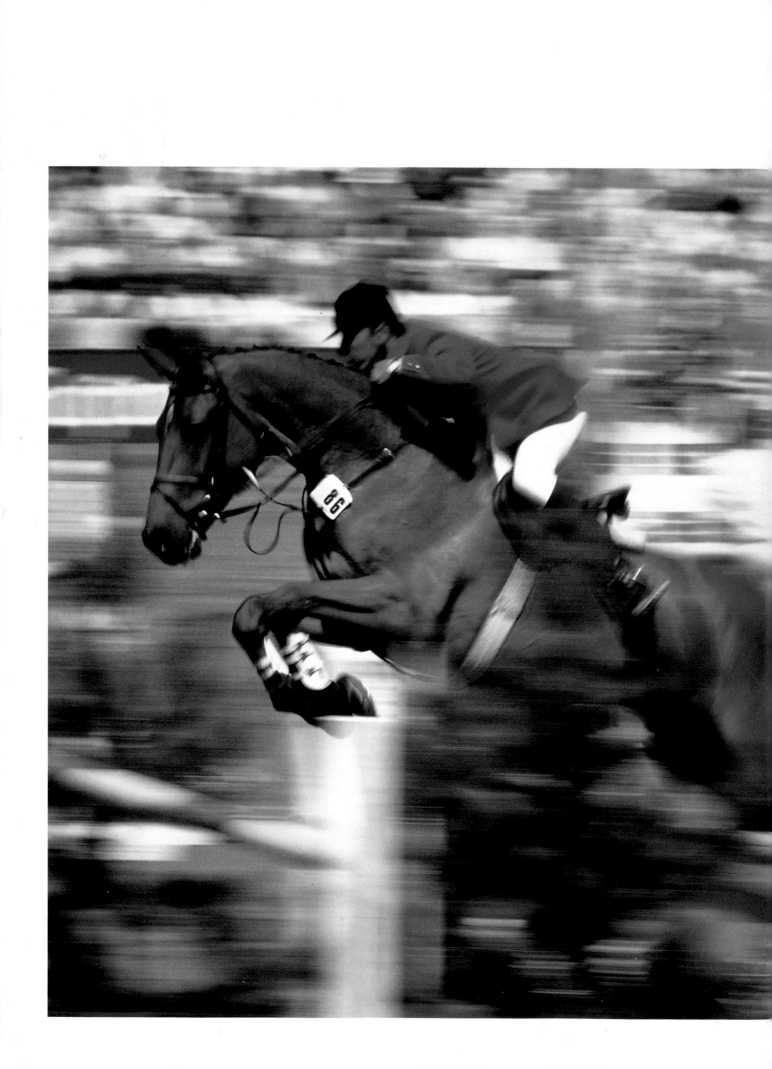

INTRODUCTION

There are a thousand different forms of sport photography. You can photograph a face grimacing with effort, the graceful curve of an athlete's body, the stillness of concentration before the event, the exhaustion at the end of a marathon. You can photograph a motorcyclist seemingly suspended in mid-air, or a skier leaning at an impossible angle as he or she hurtles through the slalom; you can make a picture in which you can almost hear the thundering of a horse's hooves, or the hiss and splash as a racing yacht knifes through the water.

Nor are the techniques you need to take such pictures confined to sport. In the broader sense of 'action' photography, you can photograph dancers, fast-moving trains, even children at play.

And yet many people never even consider this sort of photography because they labour under two fundamental misconceptions. One is that the only way to photograph sports and action is with the sort of super-lenses which cost a month's salary and more, and the other is that in order to get great pictures, you need to attend world-class events: the Olympics, the Grand National or the World Cup.

Neither of these is true. As you will see, you can take good action pictures with even the simplest equipment - even, in many cases, a compact camera. Although a more versatile camera (and more especially, a wider choice of lenses) will give better results, you can still take excellent pictures with quite modest lenses.

Likewise, there are many good pictures to be had at a local rugby club or even a junior school sports day. In fact, you can often get better, more intimate pictures at a local event,

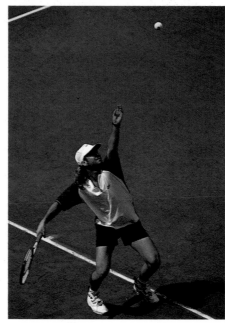

and they can prove more enduring. After all, the immediate news value of a top sportsman or athlete inevitably fades, but a truly great picture of a little-league baseball game or a village cricket match has a timeless quality because of the relative anonymity of the participants: outside the immediate circle of their friends and relations, no-one knows them, and they stand for all little-league players, for all village cricketers.

What is more, because a local event is not usually the subject of intense media interest, you can get far better access for photography. Instead of being confined to a press box, crushed in with a lot of other photographers, you can often wander where you like. This in turn means that you do not need the kind of exotic equipment that would be required at a professional event: you can get closer, so you do not require 300mm f/2.8 and 500mm f/4 lenses which weigh a ton and cost a fortune.

It is interesting, too, to reflect upon the fact that today's top sports photographers almost all started out at local events, as amateurs. They began by taking pictures for love, not money; and in most cases, they started out with very modest equipment. Everything else followed naturally: their work appeared in local newspapers and then in magazines, slowly building up until they were working for major magazines and national newspapers. In sports and action photography, as in every other field, you can never aim too high, though you can aim too high, too soon. But take the long view, take the best pictures you can and the sky is the limit.

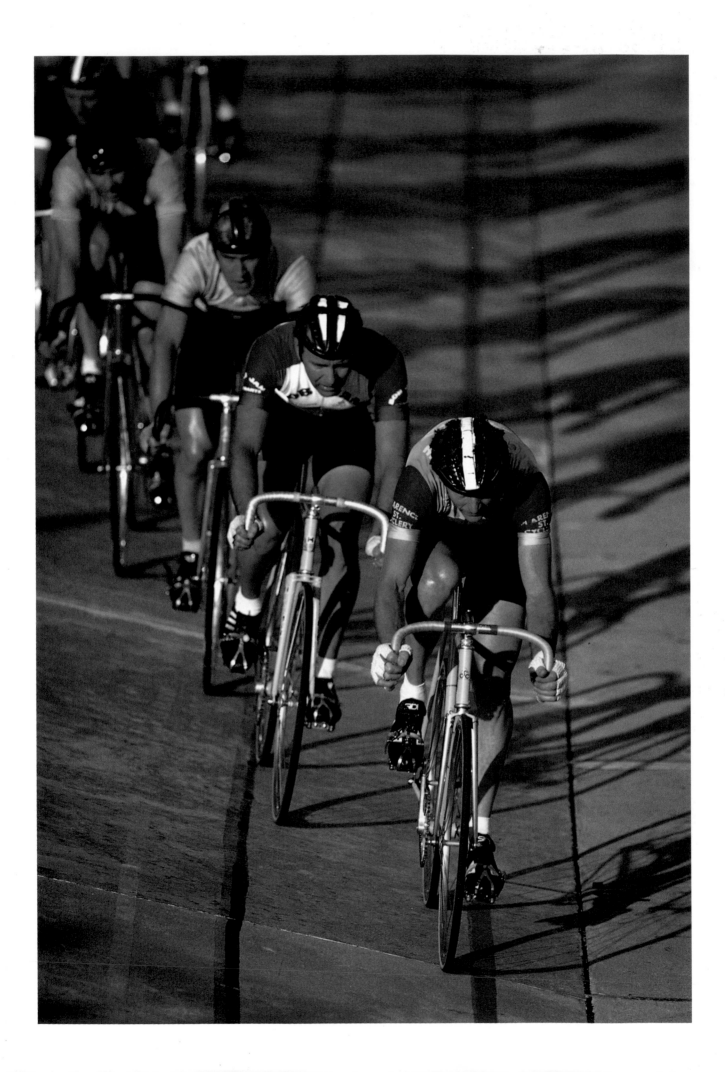

Sports photography

From a school sports day to an Olympic final, sports photography aims to capture all the spirit and drama of the occasion. Fast reactions and familiarity with the event are the keys to successful sports photography.

Whether your interest in photographing sport and action is mainly that of a fan or a photographer, a well timed shot of a dramatic sporting moment can be one of the most treasured of all your pictures.

Most sports and action occur at a fast pace. Even those activities where little seems to happen for long periods, such as cricket or golf, have short but intense bursts of high speed action.

Fast reactions are therefore essential if you want to capture the high points of an event. Make sure that you can use your camera as quickly as possible. Fumble about with the controls and you are sure to miss the crucial moments.

It always helps if you choose a sport which you know something about beforehand. You'll then be in a much better position to anticipate what the action will be from moment to moment.

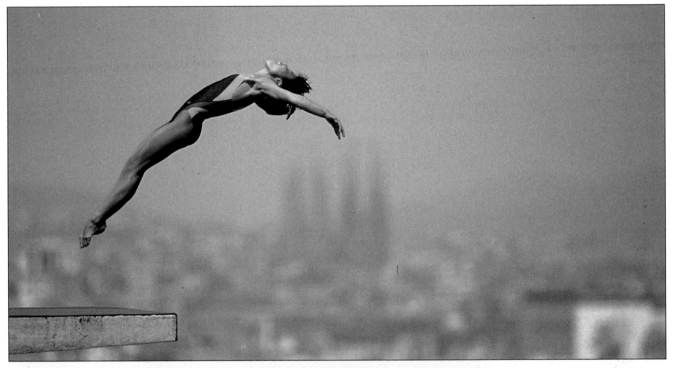

▲ **OVER THE CITY**
A fast shutter speed and a high viewpoint captured this spectacular picture of a diver leaving the board. By shooting during a practice, the photographer's choice of viewpoints was greater than it would have been during the Olympic events themselves.

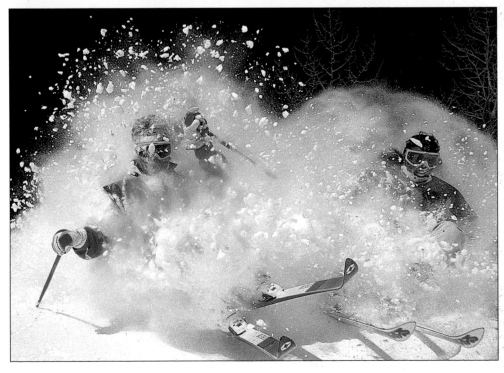

◀ **SNOW STORM**
The combination of snow, exciting action and brightly coloured clothes makes skiing an attractive subject. However, the brightness of snow can often mislead the camera's built-in meter, so the photographer set +1 on the exposure compensation dial.

Outdoor sports

One of the biggest problems the amateur sports photographer faces at professional events is a restricted choice of viewpoint.

At major sporting events, the key positions – for example, the touchline at football or an infield position at top athletics meetings – are reserved for professional photographers. For lower division or amateur matches and local athletic club meetings you should have little problem. A letter to the club secretary and the promise of complimentary photographs should secure you a pass.

If you are restricted to shooting from a stand you can still obtain very acceptable results with a telephoto – preferably a 400mm or 600mm. Stand behind the goal or by one of the corner flags to capture goalmouth action. If you stand near the centre of the pitch, the players will have their backs to you when in the goal area.

At team matches it's helpful to isolate the key players around whom the match revolves. With practice you can follow focus on your principal subject – this involves continuously refocusing the lens.

Sometimes you will find that a player or athlete is lost in the background of spectators and stands. You can avoid this by using the largest aperture available. This will throw the background out of focus and make your subject stand out. A low viewpoint of your subject against the sky – a high jumper, for instance – can also produce a very dramatic picture.

telephoto lens blurs distracting background

fast shutter speed freezes action

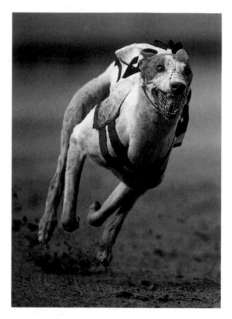

▲ **SPEEDY GREYHOUND**
With the subject approaching head-on, a shutter speed of 1/500th sec was used to freeze the action.

▼ **TOUCH DOWN!**
The photographer used a telephoto lens to fill the frame with the rough and tumble action of these colourful American footballers.

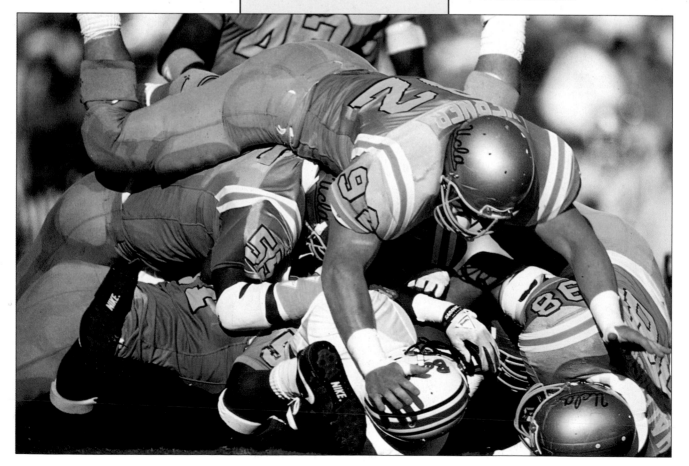

Indoor sports

Sports which take place indoors – boxing, basketball, table tennis and showjumping are just a few examples – can pose a different challenge for the photographer, largely as a result of the low lighting conditions combined with the fast shutter speeds necessary to freeze action.

At indoor events, experiment with different viewpoints. Most venues are fairly flexible and there shouldn't be any problem moving around the aisles. But remember never to block the view of other spectators. If you are unsure, you should play safe and pay for a front row, or 'ringside', seat.

Fast lenses are all but essential at indoor venues, and fast wide-angles are often the most useful of all if you want to photograph such events. They can capture a far larger scene than a telephoto, and the risk of camera shake is less. A box-ing ring surrounded by a mass of spectators, for example, can catch the atmosphere of an event as successfully as a close-up of the fight itself.

Look out for moments of concentration such as a badminton player waiting to receive serve. You can use slower shutter speeds – 1/125th sec should be sufficient – and these still images make a good contrast with more active subjects.

◀ **PERFECT CO-ORDINATION**
Indoor sport often takes place in poor lighting conditions. Look out for moments where the action slows down and you can use a slower shutter speed, as in this shot of a gymnast balancing on a beam.

Tip **Lighting**

Indoor lighting is usually warmer in colour than daylight, so use a tungsten balanced film. With daylight film you'll need to use a deep blue 80A filter for correct colour, and this will force you to use a much slower shutter speed.

Uprating film lets you use faster speeds, but the grainy results may prove unacceptable. Often, it's better to give in and accept a colour cast on fast daylight film if you want to retain fast shutter speeds.

The decisive moment

Every sports photographer wants to capture the decisive moment. The moment a footballer heads the ball past the goalkeeper and the instant an athlete knows she's won a race, for example, are classic images.

Anticipation and timing are crucial. A fraction of a second in most sports makes all the difference. Fast moving action can require shutter speeds of around 1/1000th sec or less to freeze the action successfully. Remember to take into account the speed of the subject as it passes through the frame. A distant subject will take more time and is easier to shoot than a closer one. Movement towards the camera will also appear slower than movement across the frame.

A good time to capture the decisive moment on film is to shoot just before the action changes direction. Think of a pole-vaulter motionless at the top of their flight or a tennis player just before smashing an overhead winner.

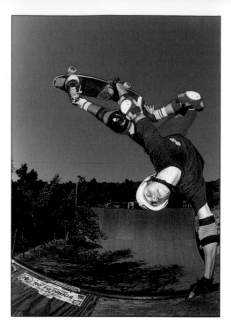

▼ GRAB THE BALL
A telephoto lens caught this dramatic moment during a rugby match. A blurred background concentrates attention on the action.

▲ ON THE EDGE
The photographer used a full-frame fisheye lens and a polarizer to take a spectacular shot of the skateboarder poised on the lip of a 'vert ramp'.

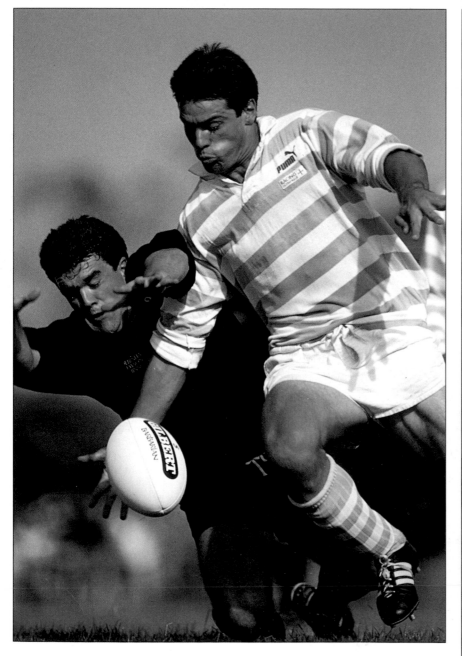

Conveying action

A fast shutter speed that freezes the moment is not the only way to photograph action. Using a slow shutter speed will create a blurred shot, which tends to convey a sense of speed and movement that you won't get with a razor sharp image.

Panning is one of the most effective ways of capturing action. This involves following your subject and keeping it centred within the frame as it passes in front of you. The resulting blurred background contrasts with the crisp subject to give a real sense of action.

Choosing the right speed for panning comes down to experience, so it's best if you experiment with a variety of shutter speeds. Once you have released the shutter, continue a smooth panning movement. If you stop as soon as the shutter has been fired the camera will jerk and ruin your results.

Another approach is to change the focal length of a zoom lens during exposure. This will produce a dramatic and exaggerated blurred effect. Slow shutter speeds of around 1/4 to 1/15th sec usually work best so you may wish to use a monopod for extra support.

▼ QUICK START
Zooming the lens during exposure conveys plenty of colour and action, as in this picture of athletes leaving their starting blocks.

zooming lens during exposure dramatically conveys sense of speed

contrasting blurred colours adds impact

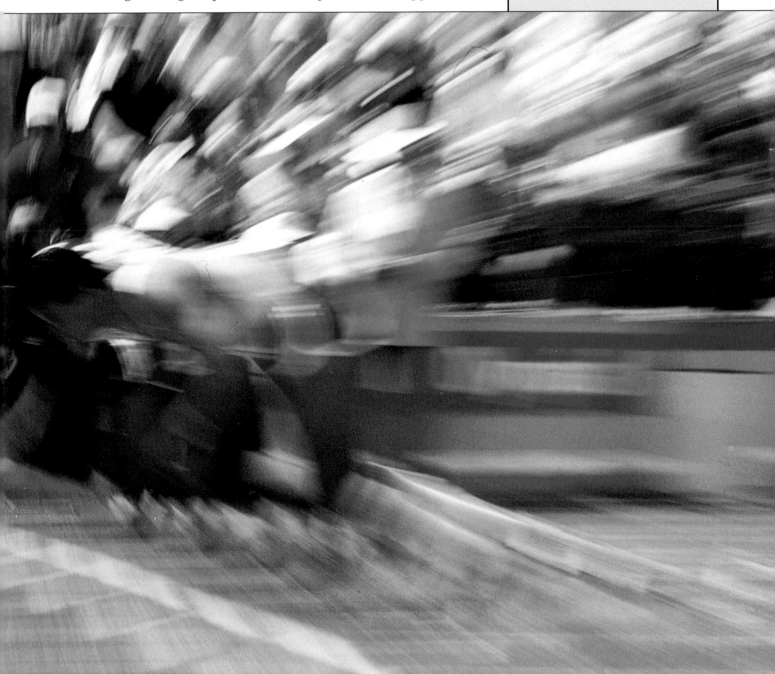

Different approaches

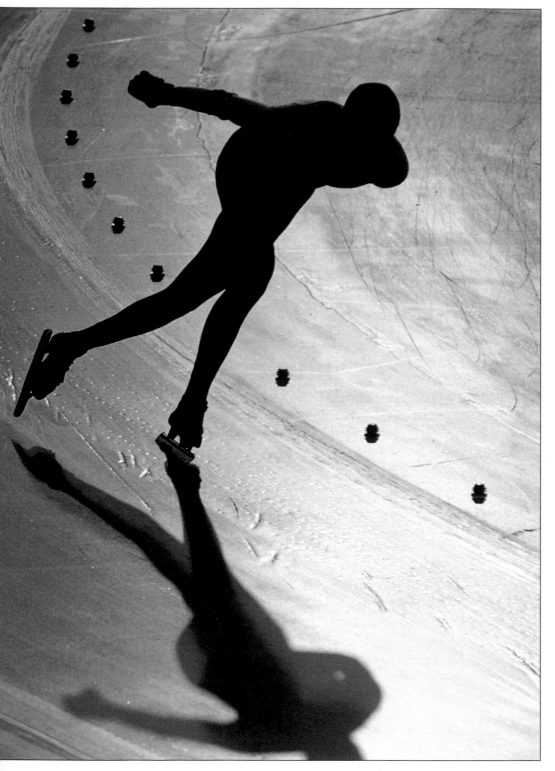

◀ RACE ACROSS THE ICE AT SUNSET
◀ RACE ACROSS THE ICE AT SUNSET
With the sun low in the sky, the photographer took an exposure reading from the ice to produce this dramatic silhouette of a speedskater and his shadow. Including the track markers within the frame puts the shot in context.

CHECK IT! ✔

When photographing sport and action:

❑ choose a sport you know well

❑ use a telephoto lens to get close to the action

❑ if you can, experiment with different viewpoints

❑ shoot at the peak of action just before it changes direction

❑ spectators' reactions make a good subject

❑ make sure you can use your equipment quickly

Sports photography is not just about catching high speed action or the winner crossing the finishing line. Sport is often full of drama that you can't find anywhere else – for example, the dejection on the defeated boxer's face, the aggression of a rugby forward or the exhaustion of a marathon runner.

Spectators can also make very good subjects. Think of football fans celebrating their team's winning goal or a proud parent's face when their child wins a school sports day race. Match officials and preparations behind the scenes can also provide less conventional material.

If you can obtain access, training sessions are an ideal time for sports photography. You'll be able to move in close without obstructing any spectators and you may even be able to obtain a posed portrait shot of your subject.

Team sports

Whether you're photographing school pupils or professional sportspeople, outdoor sports can provide you with lots of material.

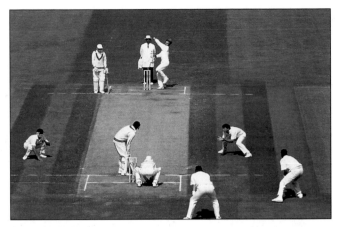

▲ *At a Test match, with a medium telephoto you can take a good general view of the wicket from the stands, as in this shot of England versus Pakistan.*

1 Location

Practise first before you try to photograph an important match. School games sessions provide good opportunities to take practice shots. But you *must* obtain permission from the teacher responsible before you start.

Otherwise, anything from football matches on your local playing fields to village cricket matches make good starting points.

From there, what you choose to shoot depends on what lenses are available to you. If you don't have access to a 400 or 600mm telephoto, you are limited to taking general shots of, say, a Test match or an international rugby game because you won't be able to move close enough to the action.

2 Shutter speed

Use a shutter speed of 1/500th sec or faster to freeze running figures. If the day is overcast, take along ISO 400 film or push colour slide or black and white print film. That way you can set the fast shutter speed you need. (Use a monopod with long lenses to avoid camera shake. It still lets you follow the action.)

3 Lens

The focal length you choose depends on both how large the pitch is and how close you can position yourself to the action.

If you're shooting a baseball or hockey match from the sidelines, a 200mm lens is enough for general action. Whatever your lens, if the players appear small in the frame when on the other side of the pitch, don't waste film. Wait until they are nearer before you release the shutter.

▼ *A knowledge of the game meant that the photographer had time to get ready for this shot. He pre-focused on the posts as the Australian team prepared to defend the goal.*

At large events, like football league matches, you need much longer lenses – 300mm to 600mm – because you probably won't be able to stand on the sidelines. This also applies when you want to isolate just one player. A 1.4X teleconverter extends the focal length of your existing telephotos without sacrificing too much lens speed.

4 Focusing

When you're focusing manually, choose lenses that you are used to. Knowing which way to turn the focusing ring makes all the difference to focusing speed.

What technique you use depends on the sport. With games like cricket or baseball which have obvious markers on the pitch (the stumps or bases) pre-focus on one of these markers and wait for the action to move near it.

Follow focus with sports like football where you can't predict where the action will go. This involves continuously refocusing on the action as players move around the pitch.

Follow focusing is difficult to master, but it is faster and more reliable than autofocus, so don't worry if you can't afford the latest equipment. It's what the professionals do.

3 lens		**4** focusing
1 location		**5** timing

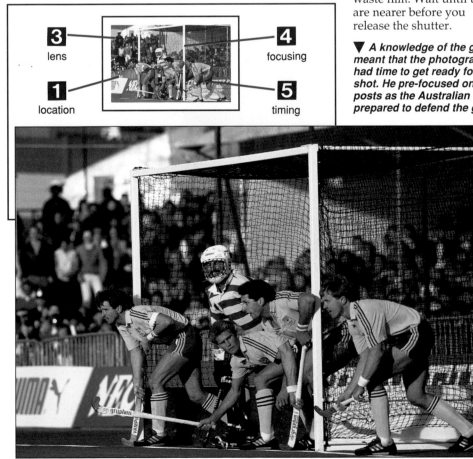

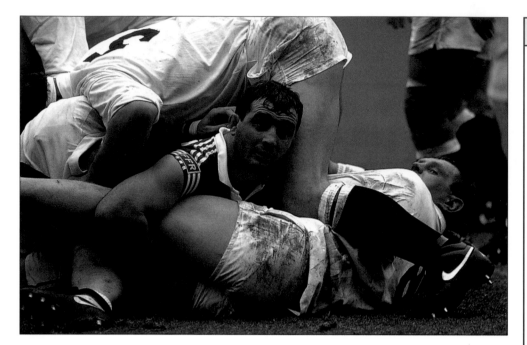

CHECK IT ! ✔

Camera: SLR. If you're worried about focusing, try using one of the latest autofocus systems.
Lens: anything from a short telephoto to 600mm, depending on how close you can get.
Film: ISO 100-400. Kodak Ektapress 1600 daylight print film can be used under floodlighting and is specially designed for pushing.
Filters: not needed.
Teleconverter: a 1.4X type is recommended if you don't have access to very long lenses and want to shoot at large events.
Motordrive: worth using for speed but don't rely on it to capture the decisive moment.
Camera support: a monopod is essential with long lenses.
Location: school, local playing field, outdoor sports centre, professional stadium.

5 Timing

Catching the right moment makes all the difference between good and stunning shots. Certain moments in a game produce the most dramatic images; goals are the obvious example.

If you see that the action is moving towards the goal area, raise your camera to your eye. But you'll need fast reflexes and luck to capture unpredictable events like falls.

A rugby scrum makes a good subject; it's an even better image if you catch the moment when the scrum half retrieves the ball.

Or if you want to record a goal in football, capture the instant the ball goes past the goalkeeper's hands. This makes a more dynamic image than if you wait until it's lying in the back of the net.

Although a motordrive can produce a good

▲ *If you want to pick out faces in a rugby ruck, as here, you'll need a very long telephoto lens – not to mention fast reflexes.*

sequence of shots before, during and after the scoring of a goal, only practice and spot on timing will capture the most dramatic moments.

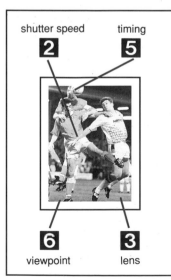

shutter speed timing

2 **5**

6 **3**

viewpoint lens

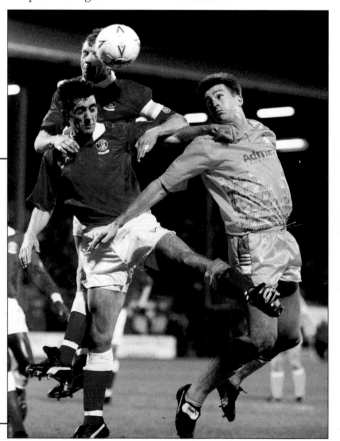

6 Viewpoint

At big matches, study a plan of the stands in advance and reserve a place where you know you'll have a good view of play.

At a football match, don't position yourself near the halfway line, as the players will face away from you much of the time. Be near a corner, so that you can capture goalmouth action. Don't position yourself behind the goal because the net obscures the action.

If one team is considerably stronger, position yourself at their opponent's goal end. You'll see more action there.

◄ *For workable shutter speeds with floodlighting, use fast daylight balanced print film and push it if it's designed for this. A lab can correct a colour cast.*

Photographing football

With its constant movement over a huge area, football can be a very difficult sport to photograph. Frank Coppi and David Jones try to follow this popular and fast moving game.

Frank and I chose an English First Division game between Arsenal and Crystal Palace for this football masterclass. We arrived at Arsenal's Highbury ground in North London an hour before kick off. This gave us plenty of time to find a good vantage point.

In deciding where to set up, Frank was more concerned with the relative strengths of the two sides than he was with either the weather or the lighting conditions. Since Arsenal are a much stronger side than Crystal Palace, he reckoned most of the action was likely to take place in front of the visitor's goal. So we positioned ourselves behind it and waited for the match to begin.

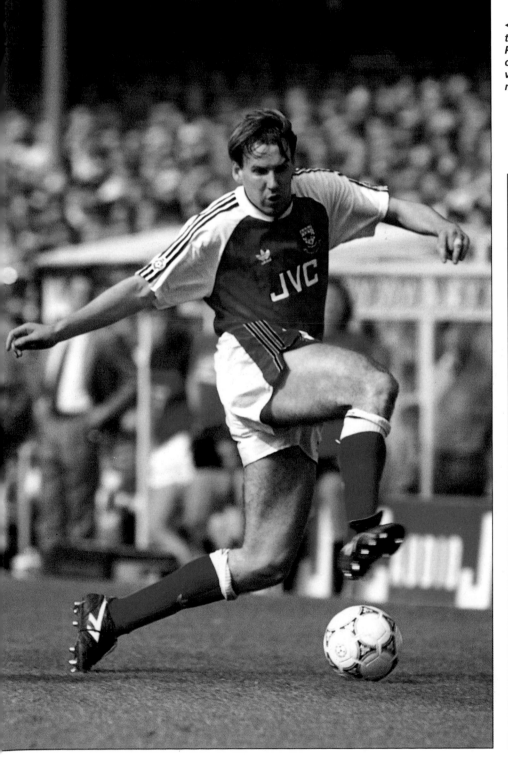

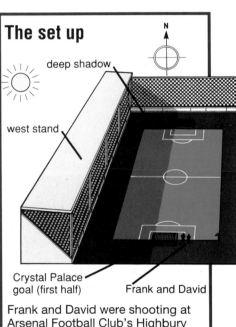

◀ *Frank used his 300mm lens to take this exciting close-up of Arsenal striker Paul Merson skilfully controlling the ball on the run. He had to refocus manually very quickly in order to catch the moment.*

The set up

N

deep shadow

west stand

Crystal Palace goal (first half)

Frank and David

Frank and David were shooting at Arsenal Football Club's Highbury Stadium in North London. As it was mid-afternoon the sun was shining in from west of the stadium, leaving one side of the pitch in strong sunlight and the other side in the shadow of the stand. All the photographs were taken from a position on the touch line behind and to the right of the Crystal Palace goal.

When the teams changed ends at half time so did the photographers. Only members of the press are allowed on to the ground during a professional football match, but anyone can do this in an amateur or non-league game.

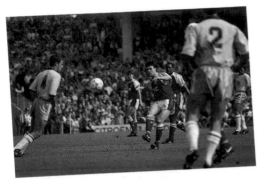

▲ *David found it very difficult to follow the ball and stay in focus, as this shot clearly illustrates. There's plenty going on, but there are too many players in the frame and most of them aren't in focus. It wasn't a particularly dramatic moment either.*

FOLLOWING THE ACTION

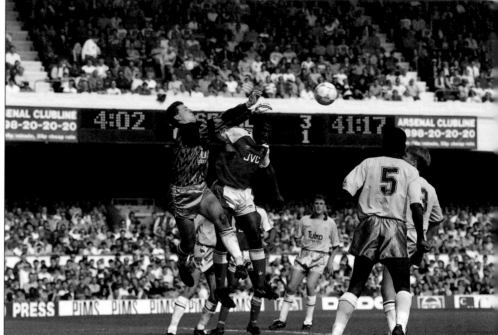

Tip

Fast shutter speeds

'A shutter speed of at least 1/500th sec is necessary if you're looking for sharp action shots', says Frank Coppi. 'Even at 1/250th you sometimes get blur. With shutter speeds as fast as these you'll probably end up with the aperture wide open. But don't worry about that – it can't be helped. All it means is that you're left with a narrower band of focus to play with.'

1 ▲ **A SPECTACULAR SAVE**
Seeing that Arsenal were advancing rapidly towards the Crystal Palace goal, Frank switched to the camera with the 135mm lens and waited for the ball to appear in the frame. He was rewarded with a high cross that was punched away by the goalkeeper before the airborne attacker could reach it. The lens has thrown the crowd behind slightly out of focus so they're not too distracting.

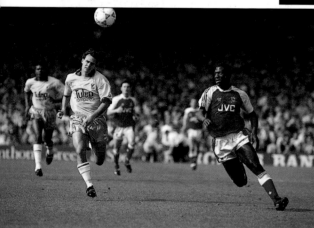

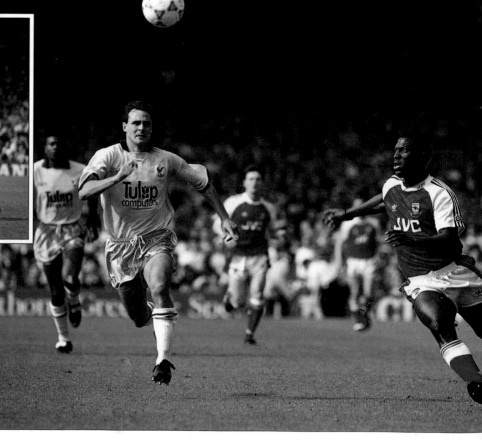

2 ▲ ▶ **AN ATTACKING SEQUENCE**
When Frank saw that a chase was on for this long pass, he focused on the attacking Arsenal player Kevin Campbell and kept shooting. The result was this exciting series which shows him chasing the ball, catching it up and controlling it after it has landed, followed closely by a desperate Crystal Palace defender. Frank had to make continual minor focusing adjustments in order to keep Campbell sharp as he moved forward.

A breakneck start

Once the whistle blew I was amazed at the speed of the players around the park. I was using a Nikon F801, Fuji ISO 100 slide film and manual lenses, and I found it very difficult to stay in focus as I tried to follow the ball. I alternated between a 135mm lens for goal-mouth action and a 300mm lens for longer shots, but often missed a shot while trying to change them.

Lighting was another problem. It was a lovely sunny day, but the sun was shining down from slightly west of the ground, leaving half the pitch in bright sunlight and the other half in a deep shadow cast by the stand. This meant that the exposure reading differed as play moved around, but I didn't always have time to adjust accordingly.

With correct exposure and picture sharpness so difficult to achieve I knew I was up against it, and most of my pictures suffered as a result. Timing was also difficult, and I never managed to release the shutter at the decisive moment.

Experience and technique

Frank is a very experienced football photographer, and has developed a way of working to suit the difficulties of covering the sport. He loaded two Nikon F4s with Fuji ISO 100 film, then put a 135mm lens on one and a 300mm lens on the other. This meant he was able to switch focal lengths without changing lenses. Then he sat down on his metal camera case, mounted the camera with the heavier lens on a monopod and started shooting.

He's well used to focusing at speed, and knows what sort of situation makes a potentially good action photograph. 'Most amateurs set out to photograph a goal', says Frank, 'but they don't actually make very good photographs. It's tackles, high balls and tussles around the goalmouth that provide the best pictures. So that's what I usually look out for.'

A glut of action

The game started with a shock goal at the other end for Crystal Palace.

But Arsenal soon replied with a spectacular hat trick that justified Frank's decision to stay behind the Palace goal mouth. With all that goal scoring action going on there were bound to be a few good pictures floating around.

Frank began with a photograph of a spectacular aerial save, and then took a great series of an Arsenal attacker chasing and catching a long pass. 'I saw him following the ball', says Frank, 'so I locked on to him and kept shooting – it's always worth trying that if you see an opportunity because if you're lucky you'll end up with a dramatic-looking sequence.'

At half time we switched ends with the teams. In the second half, Frank used his 300mm lens to photograph the ball controlling skills of the Arsenal players at close range, and was careful to open the aperture a little more when shooting in the shade. He finished off with a shot of a rare moment of celebration between two defiant Crystal Palace defenders.

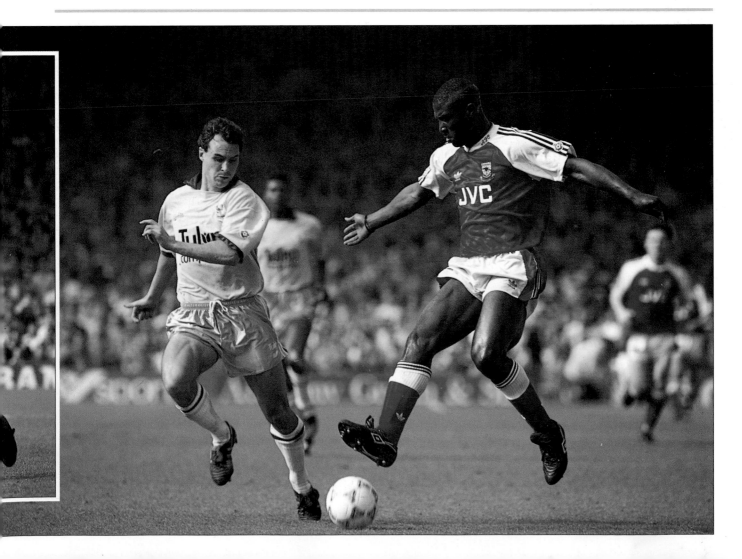

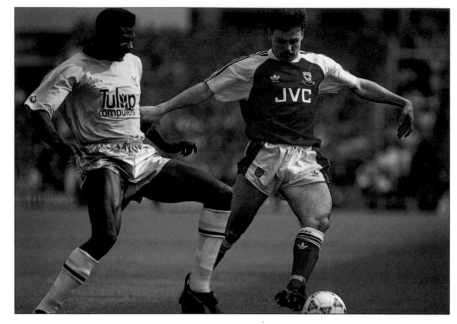

Compact tip

Using a compact to photograph football will impose severe limitations on what you can achieve. Your biggest zoom capability is likely to be 105mm, so you'd be wasting your time trying to take pictures of a big game from the stands. If you're covering a club game where you're allowed on the sidelines, position yourself behind the goal and concentrate on the close action around the box.

SLR tip

If you have an advanced autofocus SLR you'll find its speed useful for photographing football. You should be able to refocus in a split second automatically, which will increase your chances of getting the shot. But be careful – most autofocus cameras need something in the centre of the frame to focus on. A motor drive will be very handy for quick reloading.

3 ▲ BALL CONTROL
Frank took this shot of Arsenal winger Anders Limpar dodging a tackle late in the second half, with the 300mm lens. It was an awkward photograph to judge because the players were half in sunlight, half in shadow. Frank decided to open the aperture up a stop to make sure he was getting enough light.

4 ▼ CELEBRATION
Although they went on to lose the game 4-1, Crystal Palace did have their moments as this shot proves. An Arsenal attack had just been foiled when Frank noticed these two defenders congratulating each other on their sterling work. He switched to the long lens just in time to catch the moment.

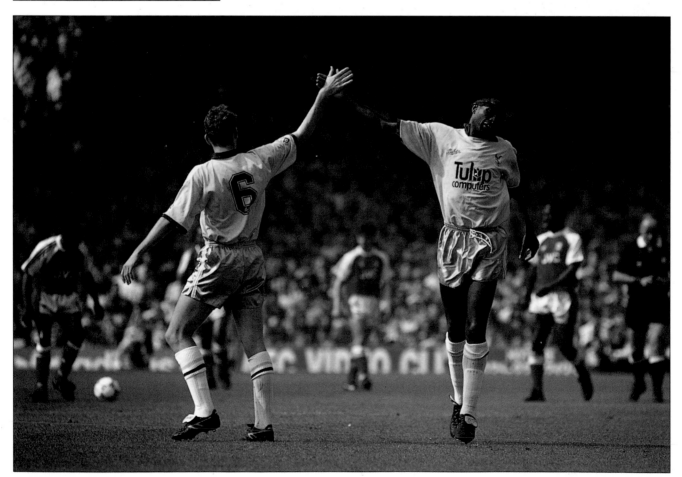

Photographing a rugby match

The set up

Frank and David were photographing a rugby league game between the London Crusaders and the Rochdale Hornets at a stadium in Crystal Palace, south London. The weather was overcast and dull, with a persistent drizzle that increased as the game went on. To cope with the bad light, both photographers used ISO 400 film and stuck with an exposure of 1/500th and f4.

They photographed the game from behind the try line and switched ends at half time. Frank used a monopod to keep his 600mm lens steady.

◀ *Frank used his 600mm lens to capture this dramatic moment around the halfway line. Because of the rain, the bad light and the distance between camera and subject, the image looks quite grainy, but it's still surprisingly sharp.*

Rugby is a fast moving and exciting game, full of spectacular running moves and crunching tackles that can look really dramatic on film. Frank Coppi and David Jones try to get the most out of a rainy rugby league match.

Before Frank Coppi and I set out to do this masterclass, we had to decide which version of the game we wanted to photograph – rugby league or rugby union. It was hard for me to decide because I enjoy. watching both versions, but Frank suggested we choose the professional or league version.

'It's a faster moving game than rugby union', he explained, 'so we're guaranteed to see a lot of running movements.' In England, most rugby league is played in the north of the country, but we chose a London venue for our game, a first division tie between the Rochdale Hornets and the London Crusaders.

Setting up

Frank knew that the Crusaders were the stronger side and therefore likely to score more points, so we positioned ourselves behind the Hornets' try line and waited for play to begin. 'Some photographers like to shoot rugby from the sidelines', says Frank, 'but I prefer to be behind the posts so the players are running straight at the camera.'

We may have been in the right position, but the weather wasn't exactly in our favour. It was dark, overcast and the drizzling rain was getting worse by the minute. To cope with the bad light, we loaded our cameras with Fuji RHP ISO 400 slide film and hoped that conditions would improve as the game went on.

▲ *Early on in the game, David made the mistake of shooting outside the range of the 300mm lens he'd chosen, which left the players looking very small in the frame. As you can see, he also had severe problems focusing manually at speed.*

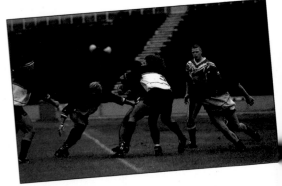

▶ *This is a better shot. The players are within the range of David's lens and are all in sharp focus. Unfortunately the player in possession has his back turned so that neither his face nor the ball can be seen.*

Missing the moment

The Rochdale Hornets started well and made us wonder if we were sitting at the right end of the pitch, but within a few minutes the London Crusaders were dominating the game and starting to attack. I was using a Nikon F801 and a 300mm lens, and took my first shots when play was still in midfield at the start of the game.

Unfortunately, this was a little outside the range of my lens, leaving the players looking far too small in the frame. I also had trouble keeping my shots sharp, but by the time play moved up our end I'd managed to come to terms with focusing at speed. I took some reasonable action shots around the 22 metre line, but found it very hard to capture a moment where both the ball and the players' faces were clearly in view. Timing a good sports picture of a fast moving game like rugby isn't easy.

A selective approach

Frank's approach was far more selective than mine. He knew the sort of incidents that would make good action shots, so he didn't waste too much film on scrappy play. His main camera was a Nikon F2 with a 600mm lens which gave him lots of range, but he also had

GETTING THE TIMING RIGHT

1 BATTLE IN MIDFIELD
Frank took this shot of the Crusaders and Hornets fighting for the ball early in the first half. There's plenty of action, but the players are a little far away for even the 600mm lens to cope with, and in the rain and dull light their faces aren't very sharp.

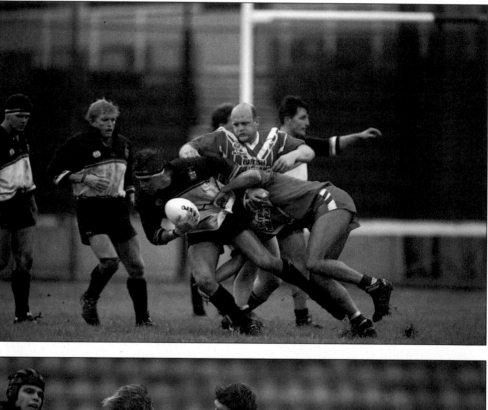

 SLR tip

You'll find a selection of lenses very useful when photographing rugby. A powerful telephoto lens is obviously the most important, at least 400mm if possible, but a few shorter lenses will enable you to keep shooting when the play moves closer. Frank had a 600mm lens, a 300mm lens and a 135mm lens for very close work, and this is an ideal combination. If you have two bodies, all the better – that will allow you to switch lenses quickly.

2 A HARD TACKLE
This is a more exciting picture. You can almost feel the crunch as the London players tackle the Rochdale man, and the referee adds a splash of colour on the right. But the shot would have been far more effective if the face of the player with the ball had been visible.

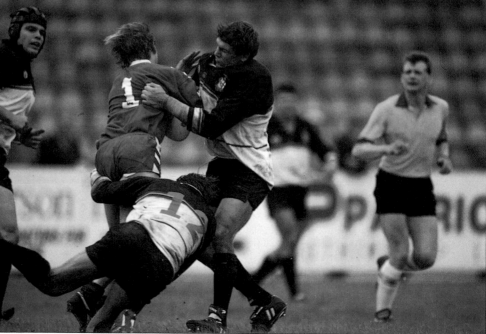

an F3 with a 300mm lens standing by for action nearer the try line.

He started by photographing a series of spectacular tackles around the halfway line. The light was so bad that he had to stick to an aperture of f4, but even with this narrow band of focus he managed to keep everything sharp. He also took an unusual picture of a player preparing to take a penalty, but his best shots came in the second half.

Switching ends

At half time the teams switched ends and Frank decided to change with them. The London Crusaders were winning comfortably and he wanted to be behind the posts they were attacking. He used the 300mm lens to capture some gritty tackles, but switched back to the 600mm lens for his best picture, a spectacular shot of a Crusader running past a tackle.

'If you're going to cover rugby league', says Frank, 'it will help if you know what sort of action you want to photograph beforehand. Strong tackles and battles for the ball make good shots provided some of the players are facing in your direction. A man running with the ball will only make a really strong picture if other players are trying to tackle him – on his own he's not so interesting.'

3 THE KICKER Just before the end of the first half the London Crusaders were awarded a penalty, and as the kicker lined up the ball Frank took his picture. He's managed to capture the look of complete concentration on the player's face as he prepares to take the kick.

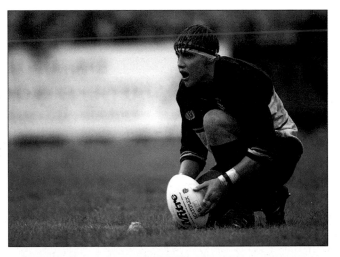

4 BREAKING THROUGH At the beginning of the second half, Frank was preparing to move down to the other end of the ground when the Rochdale Hornets launched an unexpected attack. Within moments he had set up his camera just in time to catch this player breaking through the Crusaders' defences.

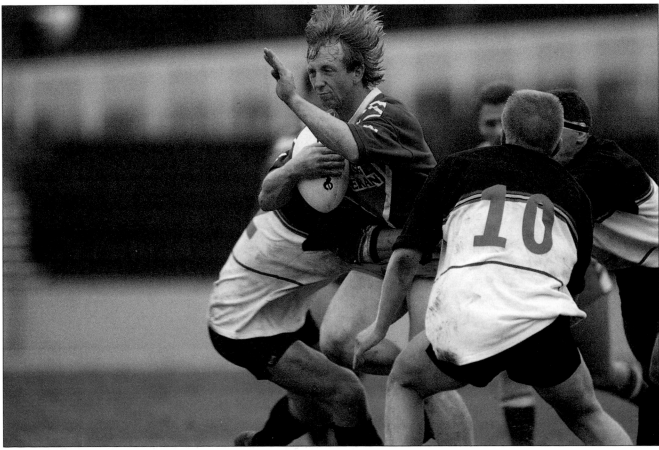

Tip

Photographing rugby union

While there are many similarities between the two versions of the game, rugby union offers the photographer a slightly different challenge. While you can't always be sure of getting the open running play you do with rugby league, there are plenty of repeated set piece situations like line outs and scrums that always make good pictures.

An eight man scrum can look very effective, especially if it's a cold day and the steam is rising from their backs. Line outs occur when the ball is kicked into touch, and if you stand right in front of the players on the sideline you're sure to get an interesting shot when they begin jumping for the ball. There are no line outs in rugby league, and while there are scrums they only involve six men and are usually over very quickly.

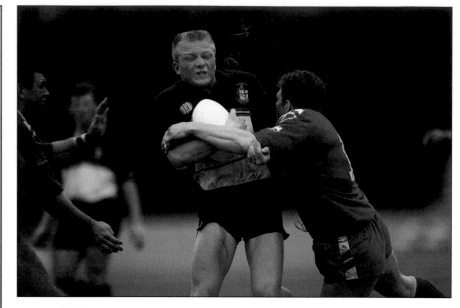

5 ▲ SHOWING THE PAIN

When he reached the other end, Frank switched to the 300mm lens as the London Crusaders advanced on the try line. They were quite close when he took this gritty shot of a Crusaders player really showing the pain as he tries to break through the tackles.

6 ▼ RUNNING MAN

Frank's best shot of the afternoon came at the end of the second half, when a Crusaders player picked up the ball in midfield and began running for the line. He reverted to the 600mm lens to capture the moment when the player swerved past a desperate diving tackle.

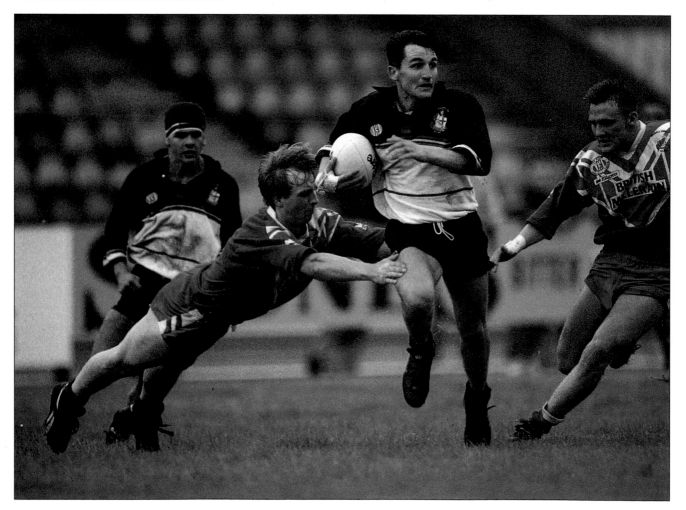

Covering a cricket match

Because all the important action takes place within a small area, cricket is an easier sport to photograph than most. Frank Coppi and David Jones zoom in on the bowlers and batsmen.

Cricket is a very photogenic game. There's always something happening around the wicket, and the white outfits make the players look all the more dramatic. On a sunny day the opportunities for spectacular action shots are endless – provided you're using a powerful enough telephoto lens. If you don't have one, you can hire one by the day from most photographic shops. You leave a deposit which is given back to you on safe return of the lens.

I arrived at this English County Championship game between the counties of Middlesex and Kent in

▼ *Former England captain Mike Gatting plays an aggressive shot square of the wicket. Frank was quick enough to capture the speeding ball just before it left the frame.*

The set up

Frank and David were shooting at a large county cricket ground. The wicket was very near the east side of the ground, which made the west side useless for photography. They started shooting on the eastern boundary, then shifted to the southern boundary when the sun became a problem. They also tried shooting from high up in the stand, which was situated at the northern end of the ground.

▲ *Frank Coppi is a professional newspaper sports photographer.*

western boundary

northern boundary and stand – shot 2, David's shots

sun's path

wicket

southern boundary – batting shot below, shots 3 and 4

eastern boundary – shot 1

N

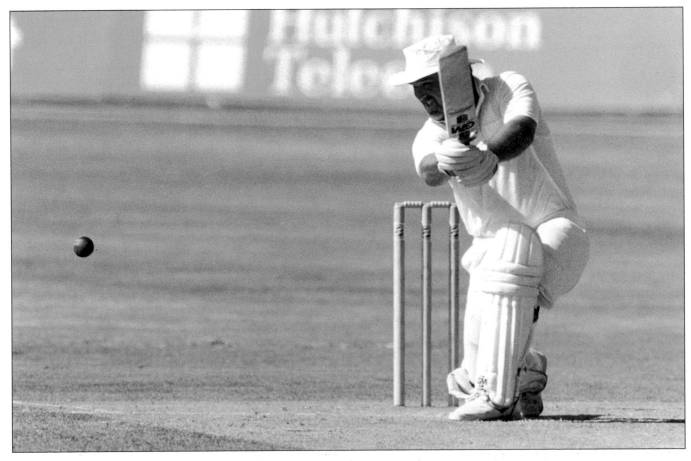

► *When David got up into the stand, he took a whole sequence of shots of a bowler delivering the ball. The pictures also included the batsman, umpire, fielders and wicket keeper, giving a good overall view of what was going on. There's plenty of movement in the shot, but as Frank pointed out, the figures are too small in the frame to give any real sense of action, so a bigger zoom or a closer viewpoint would*

have helped. He also failed to capture the exact moment when ball meets bat, pressing the shutter either too early or too late. Catching that sort of movement becomes easier with experience, and a knowledge of the sport in question also helps.

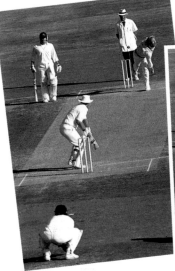

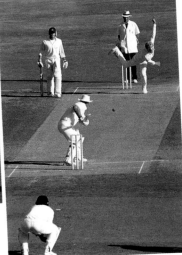

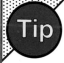

CATCHING THE ACTION

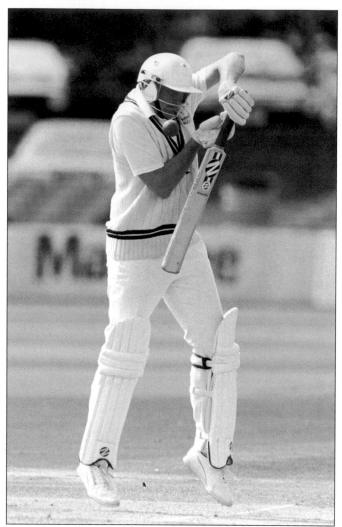

1 THE BOUNCER
When a fast bowler unleashes a bouncer, the batsman only has a split second in which to defend himself. Frank took this shot of former England regular John Emburey from the eastern boundary early in the day. Frank saw what was happening and zoomed in just in time.

Tip

Using a telephoto lens

When you're using a large lens it's important to support it properly. A hand held long tele is hard to keep steady, and even at very fast shutter speeds camera shake can ruin a shot. Frank generally uses a tripod, which he attaches to the lens rather than the camera body, but a monopod is a useful variant. 'When I was shooting from the stand', says Frank, 'there wasn't enough room to set up a tripod, so the monopod came in very handy.'

excellent company. Frank Coppi is a busy newspaper photographer who's made a career out of capturing cricket's magic moments. He knows that patience, a telephoto lens and a reasonable knowledge of the game are vital if you want to end up with good photographs.

The sun was blazing down when play started at 11am, and luckily for us it stayed like that all day. Frank and I kept shooting till play stopped at about 6.30 in the evening. We began by setting up midway along the boundary on the east side of the ground. The sun was already getting high but it was still behind our heads so it wasn't causing any real problems.

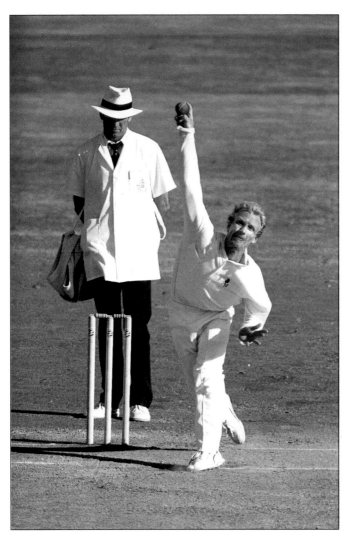

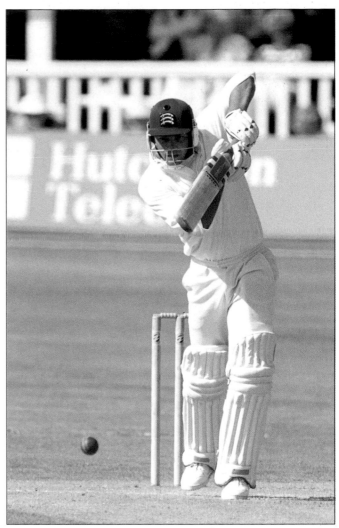

2 **THE BOWLER'S ACTION**
From high up in the stand, Frank used his 600mm telephoto lens to close right in so that the bowler fills the frame. The ball is just being released from his hand, and the shot is full of movement which is further emphasized by the stillness of the watchful umpire.

3 **THE DRIVE**
To catch this classic off-drive by England batsman Mark Ramprakash, Frank was positioned on the boundary ropes at the southern end. He guessed from the batsman's high backlift that he was planning to hit the ball hard, so he got ready and pressed at just the right moment.

The waiting game

I used a Nikon F4, a 300mm telephoto lens with a TC14B converter (which brought the focal length up to 420mm) and Fuji ISO 400 colour print film. With any long, heavy lens, a tripod or monopod is all but essential to steady the camera.

The long lens gave me a clear side-on view of the bowlers and batsmen at work. All I had to do now was wait for a suitably dramatic moment and start shooting – or so I thought. But I soon found that catching the split second when bat hits ball is far from easy. I kept pressing the shutter either before the ball had been bowled or long after it had been struck towards the boundary.

By two in the afternoon the sun was shining down into our faces and beginning to cause problems. Frank decided to move down to the southern end of the ground, behind the bowler's arm, so I followed him. This was a more promising viewpoint, because whichever end they were bowling from either the batsmen or the bowlers were now facing us. By the way, you won't be popular with the players if you stand directly behind the bowler's arm and obscure the batsman's view.

I took my best shots much later in the day, when we'd shifted up into the stand at the northern end. There we had a similarly front-on view, but being higher up gave me an overview of the whole wicket. I took a sequence of bowling shots from this vantage point that I was quite pleased with.

The right moment

Frank was also using a Nikon F4 and Fuji ISO 400 print film, but he chose a massive 600mm telephoto lens for his action shots. The powerful lens allowed him to fill the frame with a single cricketer, and he used this extra range to great effect. But what really made his

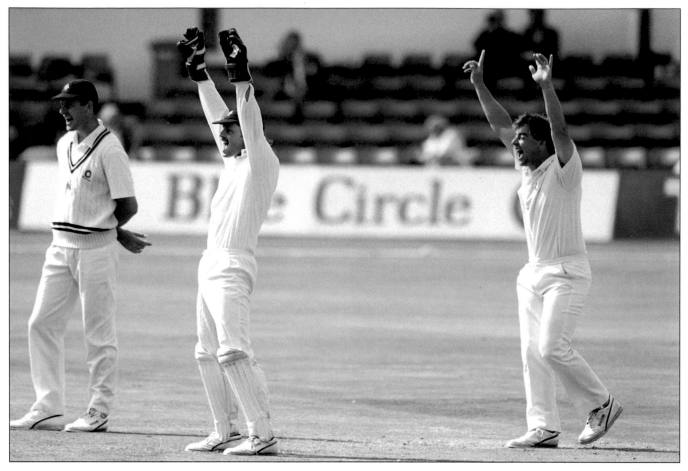

4 THE SLIPS

At the end of the day Frank turned his lens towards the slips (a line of fielders who wait for low catches behind the bat). He was rewarded with a fine shot of this exultant appeal. 'If you're looking for a decent shot of the slip fielders in action', says Frank, 'train your camera on them, forget about the rest of the players, and wait. If you're very lucky indeed, you'll get a catch.'

pictures special was his ability to press the shutter at exactly the right moment, catching man and ball in motion.

How did he consistently manage to shoot at the right moment? 'Experience is a great help', says Frank. 'I've been covering cricket for years, and I've noticed that when a batsman intends to hit the ball hard he lifts the bat up higher than usual. When I see a player do that, I always get ready to shoot. It's hard to get the timing right at first, but after a while you instinctively know when to start pressing the shutter. But for a really special sports shot you need a little bit of luck as well.'

 Compact tips

Even the most powerful zoom compact is useless if you're trying to record what's happening out in the middle of a cricket pitch. At best the players will appear as distant white specks in a sea of green. But there are some picture opportunities for compact users within the sport.

Catches and spectacular stops are often made close to the boundary, and you can easily photograph them with a compact if you're in the right place at the right time. You can also photograph the players coming in and out of the pavilion.

Rugby and football offer the compact user more of a sporting chance. Because the players follow the ball around all over the field, the action is bound to be within your camera's range from time to time. If you wait at one end you stand a good chance of getting an exciting shot of a try or goal being scored. If you're taking pictures of a sport that's unfamiliar to you, don't take a shot until you've accustomed yourself to the pace and rhythm of the play.

 SLR tips

A fast shutter speed is essential when photographing fast-moving sports action. Even at 1/125th sec, a bowler's action or a batsman's stroke will appear on film as a blur. Frank shot on 1/500th sec all day to make sure that his action images were sharp. Any speed much slower than that is not advisable.

A powerful telephoto lens reduces depth of field to a bare minimum, so accurate focusing is essential if you want sharp images. On autofocus SLRs this is not a problem, because the focusing indicators in the viewfinder will tell you when the shot's not sharp. But on manual SLRs it's worth taking a little more trouble to try to get the focusing exactly right.

On a manual camera, frequent exposure checks can mean missed shots, so use print film which has ample exposure latitude. With slides, meter occasionally, and check exposure after unrepeatable shots. If the exposure is wrong, ask the lab to push or pull the film to compensate.

Capturing a school sports day

With so much action, school sports days are trickier to record than you might think. Frank Coppi shows Sarah Jackson how a professional tackles the job.

◀ In Sarah's shot the trackside spectators are far too sharp in the frame, distracting attention away from the boys, who are slightly blurred. She's also included a figure disappearing out of the picture – pressing the shutter a fraction earlier or later would have avoided this.

We arrived at Weston Green School in Surrey on a sunny summer's morning to cover their end of term sports day. I'd heard about it from one of the teachers, and thought it sounded like a good picture opportunity, so I contacted Frank. 'Often with school events', he told me, 'you never know exactly what's going to happen until the races begin – and even then it can be difficult to tell!'

A bad viewpoint

I used a Pentax ME Super SLR and a 50mm lens. Frank suggested that I should try Ektachrome ISO 100X slide film to warm up my shots a little. The first thing to do was to find out which end the finishing line would be. I soon found what I thought would be a good spot, but I didn't realize that the track would be shortened for the very young children. I ended up losing my carefully chosen vantage point, so I decided to move round and shoot from the side of the track.

I chose a 50mm lens because it let me include most of the competitors in the frame. My viewpoint meant that while the children ran past I only had time for one shot per race, so I just pointed the camera and pressed the shutter. But I hadn't thought enough about the scene. The children are too small in the frame and almost lost against the confusing background of spectators.

The set up

All the action took place on a marked out area of grass, with parents watching from one side and children on the other. For the youngest competitors, the finishing line was halfway along the track, so for their races Sarah and Frank had to walk forward and stand in the middle of the lanes to catch a good picture. They also shot from the sidelines, over the children's heads.

A PRO'S RESULTS

1 PHOTO FINISH
Frank crouched down at the finishing line to take this shot of three young runners neck and neck, just before the boy on the left disappeared out of the frame. His choice of a 300mm lens combined with a wide aperture blurs the children in the background, and a shutter speed of 1/1000th sec freezes the action.

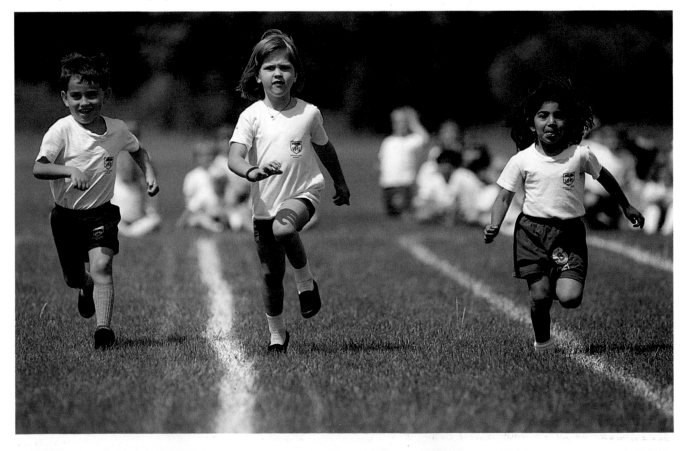

Child's eye view

Frank had brought two Nikon F4 bodies with him, one fitted with a 600mm f4 and the other with a 300mm f2.8 lens. 'Two camera bodies are useful', he explained, 'because there won't be enough time to change lenses mid-race.' Like me, he used Ektachrome 100X film.

To start with he positioned himself looking down the track. A 300mm lens let him record three children who were neck and neck, while blurring the figures in the background.

One of the beauties of primary school sports days is the obstacle race. Frank thought that the Lower I's 'bed-time' race had good picture possibilities, and he was right. He took a lovely shot of one little girl who was determined to reach the finishing line first.

Zooming in

Frank then switched to his 600mm lens, supported on a monopod. With such a long lens he could fill the frame with young participants in the relay even when they were right at the start line. A fairly wide aperture blurred the waiting boys, directing attention to the runner.

Frank decided to try a rather unusual picture, which turned out to be one of the best shots of all. While all the amateur photographers put their cameras down when the children started to move away from them, Frank kept shooting. He was rewarded with an enchanting study of a girl concentrating on manoeuvring a wheelbarrow down the track.

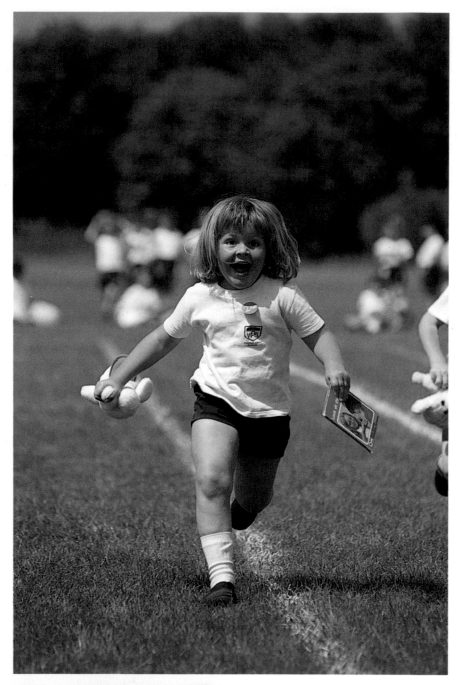

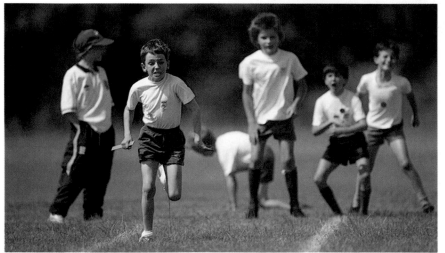

2▲ FOLLOW-FOCUS
This little girl was also taken with the 300mm lens. To make manual focusing easier, Frank follow-focused on the running figure from the start of the race. The soft toy and book add interest, but what really makes the picture is her expression.

3◄ RELAY TEAM
Frank switched to his 600mm lens so he could capture this group. The boy setting off down the track attracts your attention because he's in focus, but the other figures put the shot in context. The pose of the boy second from the right adds a touch of humour.

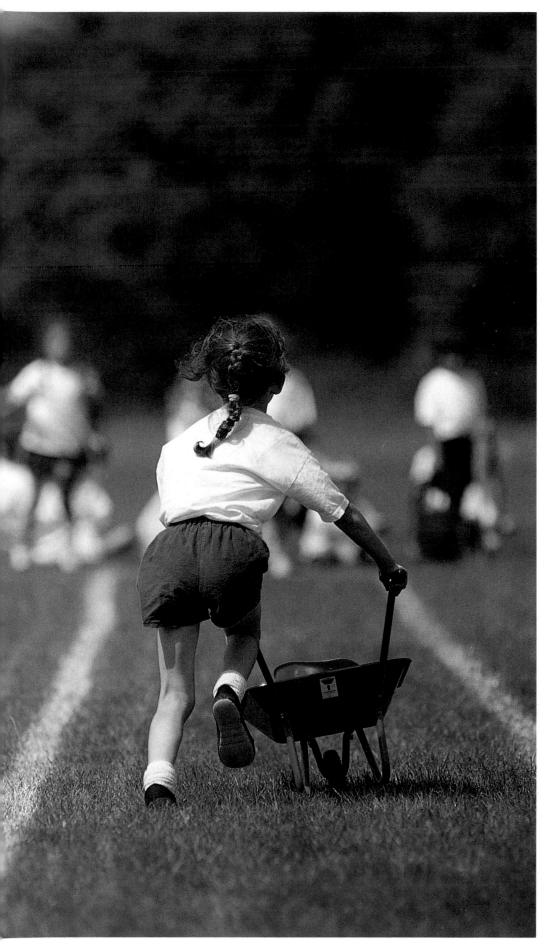

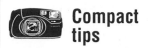 **SLR tip**

❑ Motordrives are useful at a sports day, but don't rely on them to provide a good shot. Be ready to press the shutter an instant before you want to capture the action, then use the following motordriven frames as a back-up.

Compact tips

❑ When you're at school events, remember that different age groups fill differing amounts of the frame. A zoom compact is very handy because you can rapidly change the size of the figure in the picture, while standing in the same place.

❑ If you have a fixed lens, stand near the finish and before the races begin note at which point on the track each age group fills the frame. When you press the shutter, a nine year old, for example, will have to be further away from you than a five year old to be the same size in the frame.

4 AN UNUSUAL VIEW
Even when the children were racing away from him Frank carried on shooting, and was rewarded with this amusing shot. It was taken once again with the 300mm lens. An aperture of around f4 blurs the background.

◀ Frank wanted to convey a real sense of action in this shot, so he set his 35-70mm zoom to 35mm and used a shutter speed of 1/15th sec. This kept the adult and child spectators sharp but recorded the competitors as a rushing blur of movement.

▼ When the main races were over, it was the turn of the spectators! The expressions on these mothers' faces (below) say it all. Frank darted forward to photograph the winner of the Under Fours race (bottom). The children's bright clothes make the shot really colourful. Because there was a lot of shadow, he opened up the aperture by half a stop to let more light in.

The end of the day

When the pupils' races had ended, the action wasn't quite over. For added entertainment, the staff had devised races for parents and the under fours. With great foresight Frank had brought along plenty of film with him.

From the side of the track, he used his 300mm lens to capture three enthusiastic participants in the mothers' race. He then switched to his 600mm lens to ensure the youngest winner of the day was a good size in the frame.

Viewed together, the shots succeed in capturing the atmosphere of a school sports day very well.

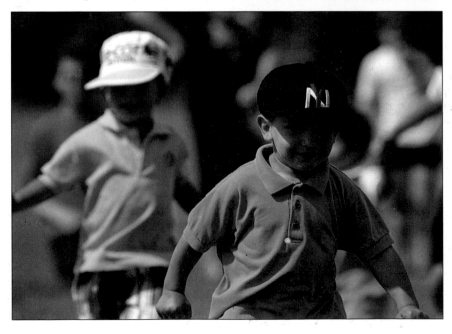

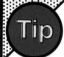 **In at the finish**

At school sports events you don't necessarily need a long telephoto lens to come up with great shots, because you can often get very close to the action. If you're allowed right up to the finishing line, why not try a standard or wide angle lens?

When you're looking through the viewfinder, figures can seem further away than they are in reality. Make sure that you aren't run over by the competitors finishing the race!

Mike Powell – Shooting sports stars

Mike Powell started out photographing his friends in local fun runs. He now photographs stars like Carl Lewis and Gail Devers at the Olympics.

Mike Powell's rise to the top of sports photography was meteoric. In 1981, at the age of 16, he left school to start working for the Allsport photographic agency in London. When he was 20, he helped Allsport set up an American branch in Los Angeles.

Now based permanently in the US, Mike has gained a formidable reputation with his photos of headline sports events including the 1988 Seoul Olympics, the 1992 Barcelona Olympics and the 1992 Albertville Winter Olympics.

▼

"This is Gail Devers hitting the final hurdle in the 100-metres hurdles at the 1992 Olympics. As you can see, she was winning at this stage, but hitting this hurdle meant she finished in fifth place. I was actually covering the long jump, but I sprinted across the stadium in between rounds. Gail was favourite so I hurriedly focused on her hurdle."
Taken on a Canon EOS 1 with a 200mm lens on Kodak Ektapress ISO 400 film at 1/500th sec and f2.

▶

"I was following the Los Angeles running back – in black – and he was caught by a horde of Dallas Cowboys. The helmets arranged themselves into this amazing pattern. American football is a very hit and miss sport. I usually take about 25 rolls of film at one match – and even then I am by no means certain of ending up with a shot as good as this one."
Taken on a Canon EOS 1 with a 400mm lens on Fujichrome RDP ISO 100 film at 1/1000th sec and f4.5.

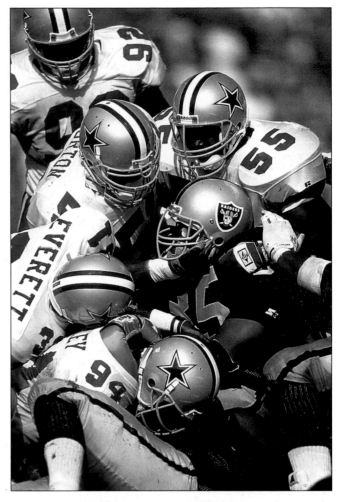

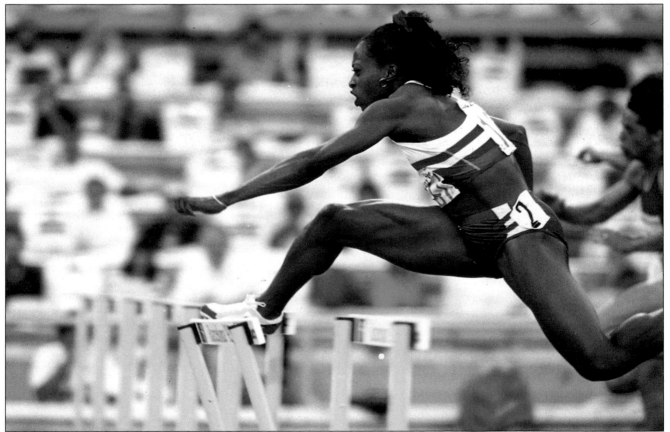

'My number one sport is athletics,' Mike states. 'I cover the Grand Prix events in Europe every summer, as well as the big events like the Olympics and World Championships. As for the American sports, I chiefly do American football. Baseball, the other major American sport, is too slow for me. One of the advantages of coming to America was that I didn't get assigned any cricket matches. I was blowed if I was going to start doing baseball, which has a similar slow pace.'

Set-up shots

Recently Mike has been doing set-up shots for sports magazines and equipment manufacturers as well as covering specific sports events. 'These shots are geared to producing artistically attractive pictures rather than simple news stories,' he says.

'They can be quite harrowing,' he continues. 'For a start, you have to come up with some ideas about how you want to pose the athletes rather than just responding to action on the field of play. I usually sketch out how I want each shot to look beforehand. Also, you've got to get the athletes interested in what you are doing. The shoot will be pretty hopeless without the athletes' help. They are busy people and you might only have ten minutes of their time, so it's high-pressure work.

"This is Carl Lewis, photographed on a shoot I did for Total Sport magazine at the Santa Monica Track Club. I wanted to get some more considered shots than would be available in competition circumstances." Taken on a Canon EOS 1 with a 600mm lens on Kodak Plus-X ISO 125 black and white film at 1/250th sec and f4.

"My agency, Allsport, had four or five photographers covering this men's downhill ski race at the 1992 Winter Olympics in Albertville. I chose a position near the top of the hill to capture the skiers coming over a bump. This Brazilian skier with his colourful costume provided me with my best shot." Taken on a Canon EOS 1 with a 400mm lens on Kodak Ektachrome Professional X 64 film at 1/1000th sec and f4.5.

'Having said that, most athletes are pretty co-operative,' Mike notes. 'In fact, I've made some really good acquaintances amongst the athletes. One of the high points of my life was the night my friend and namesake, Mike Powell the American long jumper, broke the world record at the 1991 World Championships in Tokyo. I got a photo of the jump that was shown around the world. We were celebrating long into the night after that.'

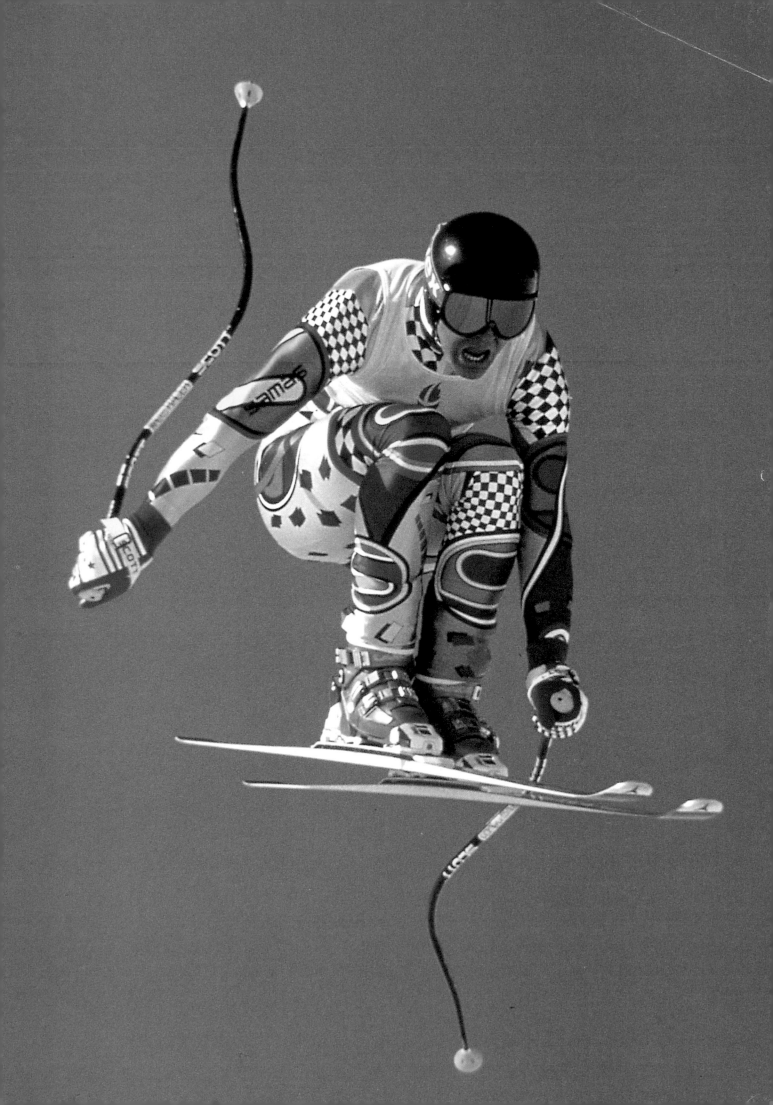

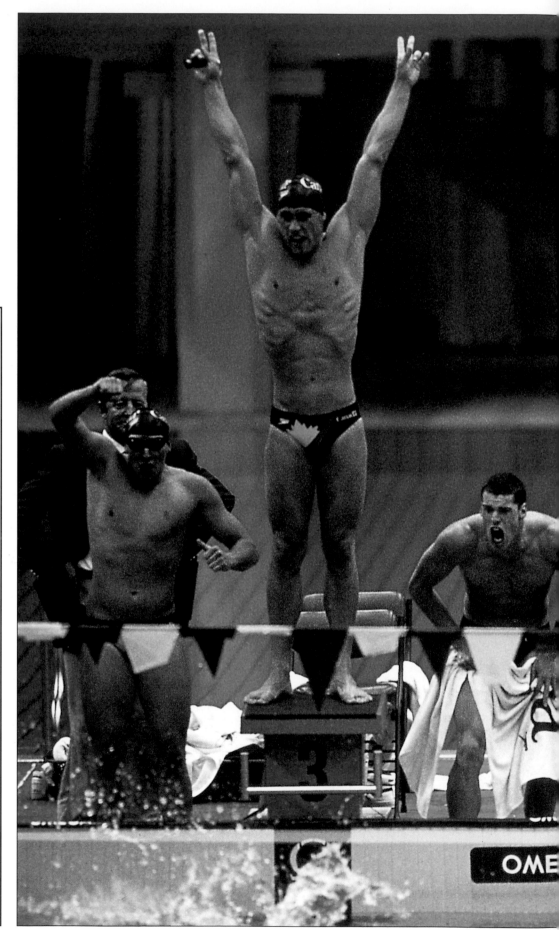

"These are the US and Canadian teams celebrating finishing first and second in the medley relay at the Seoul Olympics. I was actually at the other end of the pool to get some shots of the swimmers underwater, but as the race finished I managed to capture these victorious poses at the far end."
Taken on a Nikon F3 with a 300mm lens on Kodachrome 200 at 1/500th sec and f2.

You can do it

As a world-renowned photographer with one of the top sports agencies, Mike shoots the world's most glamorous sports events with some of the most sophisticated equipment available. However, Mike points out that he started photographing local amateur sporting events, which anyone can do.

He notes, 'I used to shoot friends in motorbike scrambling events, cross-country races and fun runs.' For these events, Mike points out that you don't have any restrictions on your viewpoint so long as you don't interfere with the action. You'll quickly learn to find the best positions from which to shoot a particular sporting event.

Mike strongly suggests photographing sports that you actually enjoy watching. 'When I was in Britain, I tried to avoid photographing cricket,' he notes. 'It's just too boring for me – I can't sustain an interest in cricket long enough to capture the one ball that really counts.'

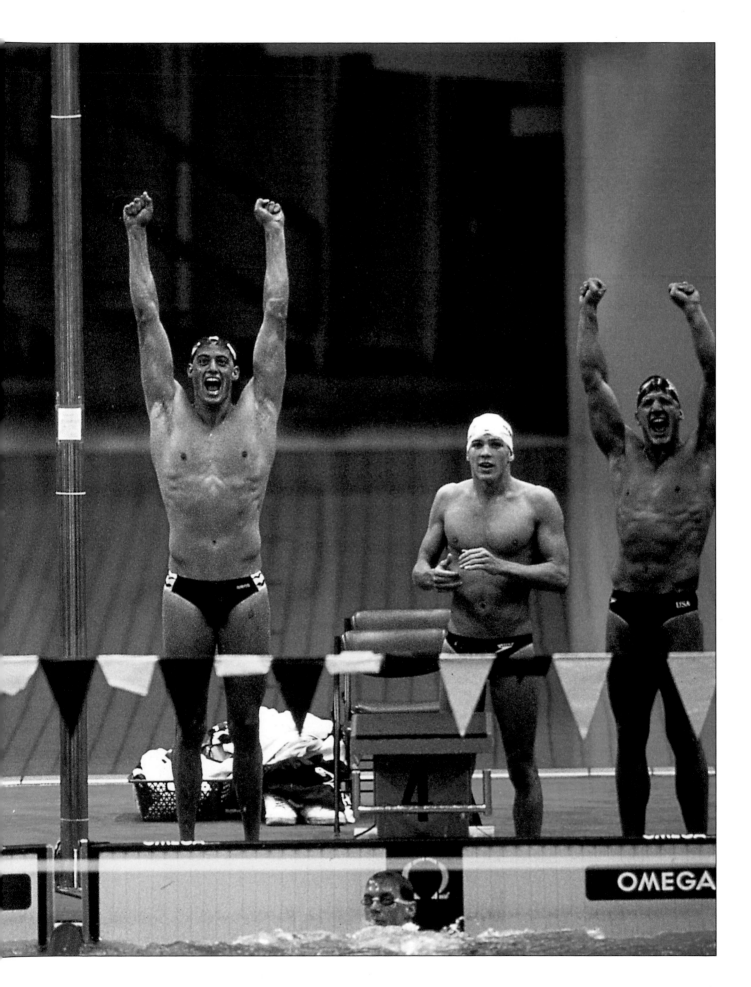

Technical details

Although Mike now uses an autofocus Canon EOS 1 camera, for the most part he still focuses manually. He explains, 'For shots like the one of Gail Devers jumping the hurdle or the one of the luge team I will pre-focus manually because you can predict where the action will end up exactly.

'Autofocus really only comes into its own,' Mike notes, 'when you are following a single person – like a runner who is yards ahead of his rivals. If there are too many bodies in the frame you can never be entirely sure what is in focus when you release the shutter.'

Often Mike switches between auto and manual focus during a passage of play. 'At the beginning of a play in American football, I will focus manually,' he explains. 'If a running back then breaks through the line of scrimmage on his way to a touchdown I'll switch to autofocus to follow him. You need a lot of practice to perfect this technique.'

▲

'This is a German double luge team banking a wall at the Albertville Olympics. They're travelling fast, so framing is a problem. I got what I wanted, though – a really tight crop on the racers' intertwined arms and legs.' Taken on a Canon EOS 1 with a 500mm lens on Kodak Ektachrome ISO 100 film at 1/1000th sec and f4.5.

▼

'I took this photograph of Santa Monica sprinter Steve Lewis from the top of a car park. I wanted to capture the stark, graphic shape of his body. Clearly, this is one of the shots you would never have the chance to capture in a competition.' Taken on a Canon EOS 1 with a 200mm lens on Kodak Plus-X film at 1/250th sec and f4.5.

Frank Coppi – Newsworthy sport

Newspaper photographer Frank Coppi has covered just about every sport you can think of. He shoots in colour and black and white, and is used to working to very tight deadlines in all sorts of conditions.

' When you're covering sports for a newspaper', says Frank, 'you have to get the picture no matter how bad the conditions are. All the paper is interested in is newsworthy photographs, so you've got to make the best of whatever a situation offers. I choose my spot on a sports ground depending on where I think the action's going to be, and that's my main priority. If the background's really messy I'll throw it out of focus, and if I'm shooting against the light I just have to put up with it and do the best I can.'

Stock sports photographers – those shooting for picture agencies – work differently. 'Because they're not working under quite the same constraints', explains Frank, 'they can spend a bit more time getting the background right and waiting for better light. Their priorities are different – they're looking for good photographs and aren't always interested in what the score is.'

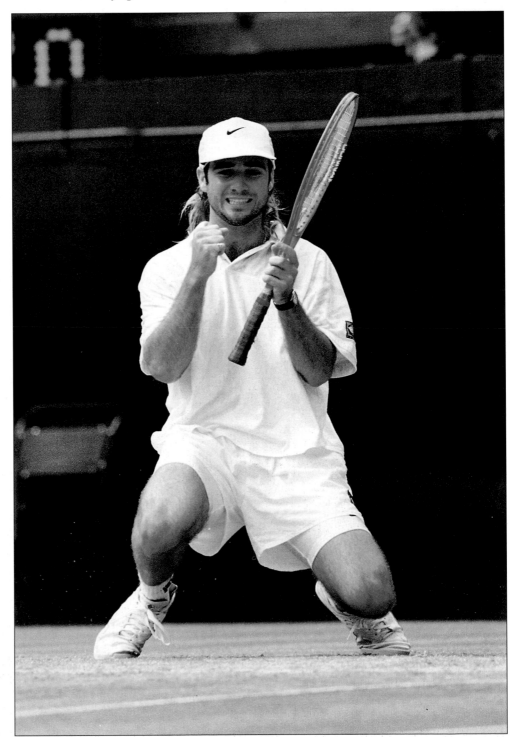

"This is the moment when Andre Agassi realised that he'd beaten John McEnroe in the semi-finals at Wimbledon. Whenever there's a match point during a tennis match, all the photographers focus on the likely winner in the hope that they'll get a nice emotional shot. Luckily for me, Agassi turned towards me once he'd won the point." Taken on a Nikon F4 with a 300mm lens on Fujicolour ISO 400 print film at 1/1000th sec and f4.5.

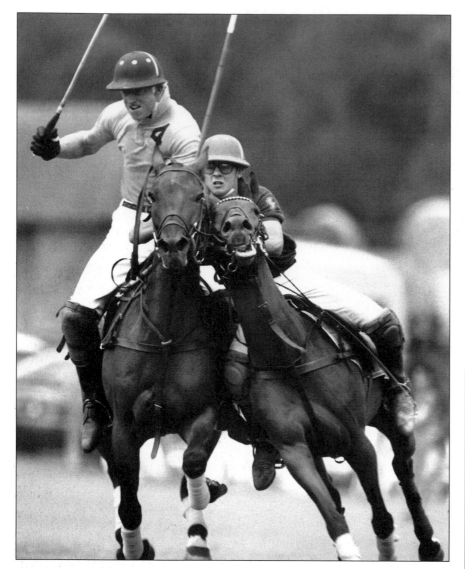

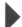

"I took this picture from the top of a diving board at Crystal Palace. The diver, Tony Ali, had agreed to let me go up on to the high board with him to try and get an unusual picture. There aren't too many options with diving and this seemed like the best bet, so I lay down flat on the board and, when he started his dive I leant over the edge and started shooting."
Taken on a Nikon F4 with an 85mm lens on Ektapress Gold ISO 1600 print film at 1/1000th sec and f4.

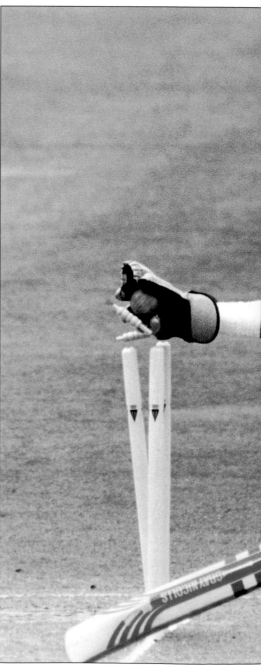

You can do it

When Frank's taking pictures for the newspapers, he's usually bound by the restrictions of time, image shape and news value, but if you're covering a sport on an amateur basis you're free to photograph whatever you want. Don't worry too much about what's going on in a game – goals in football, for example, rarely make good pictures. Concentrate instead on taking good action photographs. If you don't like the background in one part of a sports ground, you're free to move around until you find something better. The same goes for light.

Long lenses are obviously very useful for many sports, but if you haven't got them shoot within the range of what you do have. If you have shorter lenses, wait till the play comes within range before you start shooting, and try to fill the frame as much as you can. Shooting action that's outside your lens range is a waste of film.

"Polo is a very difficult sport to photograph, because the pitch is absolutely huge and even with a 600mm lens the players don't come into range very often. For this picture I positioned myself behind the goal as I would at a football match, and waited for the action to come my way. These players looked very dramatic as they jostled for the ball."
Taken on a Nikon F4 with a 600mm lens on Ektapress Gold ISO 1600 print film pulled one stop at 1/500th sec and f4.

"I took this shot at Lords during a test match between England and the West Indies. I saw that there was a chance of a run out so I focused on the batsman, Robin Smith, and tracked him as accurately as I could. It was a split second picture, because in the frame I took immediately after this one the wicket-keeper is obscured by Smith, which totally ruins the image."
Taken on a Nikon F4 with a 600mm lens and a 1.4X teleconverter on Fujicolour ISO 400 colour print film at 1/1000th sec and f5.6.

Determined start

Frank began his career by covering a football match on spec and bringing the results into the *Daily Telegraph*. 'I'd always been a very keen photographer', he explains, 'and I love sport, so it seemed like the logical thing to do. I took some reasonable pictures at a football match, and luckily for me the *Telegraph* liked them. After that, they started phoning me up and sending me out on commissions. It was mainly football at first, but I soon branched out.'

Frank still works mainly for the *Daily Telegraph*, and now covers a wide variety of sports including football, cricket, rugby, racing, tennis, athletics, swimming, diving and hockey. Football is my favourite sport', says Frank, 'but it's also the most difficult to photograph. It's very fast moving and unpredictable, which makes focusing difficult. The most important thing when you're covering a fast sport is not to panic. If you're very jumpy you're likely to release the shutter too soon and miss the moment.'

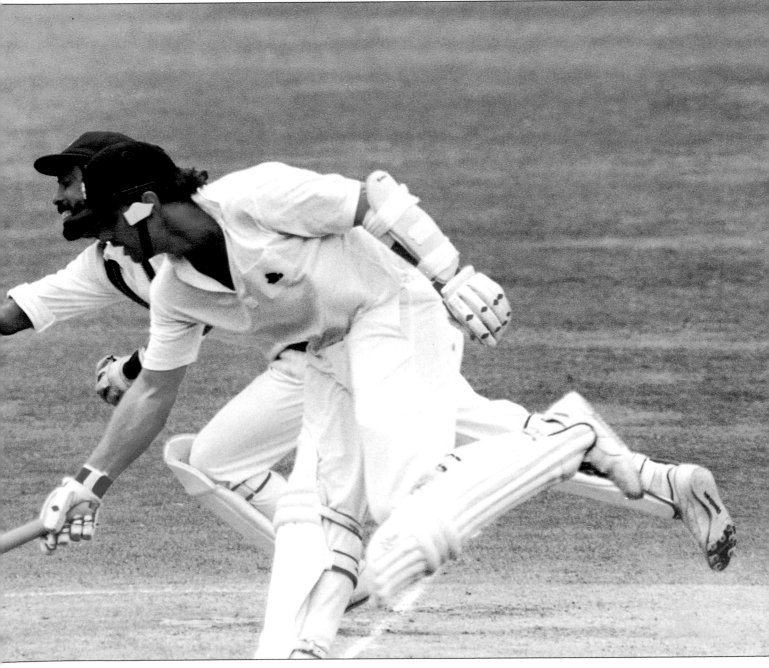

"This photo was taken at a table tennis tournament under very poor lighting conditions. I only had a few minutes to get a snap before I left, and it's difficult to focus with this sport because the movements are very quick. Thankfully, this player stepped into an overhead light at just the right moment, and the crowd behind were thrown into darkness."
Taken on a Nikon F4 with a 350mm lens on Kodak T-Max ISO 3200 print film pushed one stop to cope with the lack of light at 1/500th sec and f2.8.

"This shot of Chris Waddle beating a defender was taken at Wembley during an international between England and Yugoslavia. Photographing football at night under floodlights is very tricky, but the fast black and white film I used here performed very well. At ISO 3200 in colour you'd have nothing like the same sharpness."
Taken on a Nikon F4 with a 300mm lens on Kodak T-Max ISO 3200 black and white print film at 1/500th sec and f2.8.

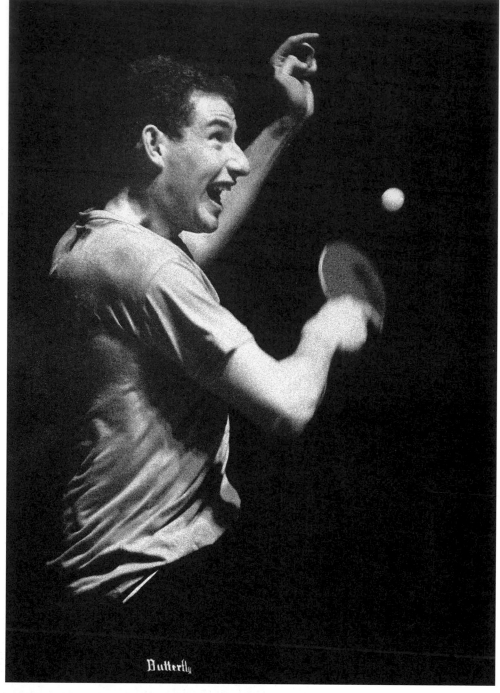

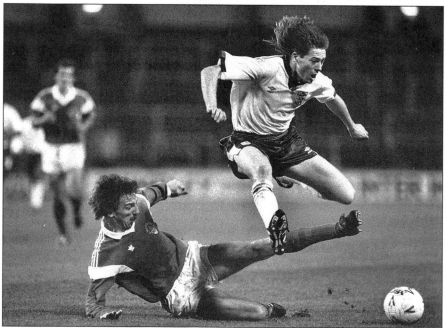

Technical details

Frank always focuses manually when photographing football. 'The game moves around and changes direction so much that it makes follow focusing very difficult', he explains, 'and there are times when autofocus would come in very handy, but overall I prefer to work without it. If I take a picture that's very newsworthy, I can get away with it not being perfectly in focus, but with AF you're either totally sharp or completely out of focus, which means I might end up not getting the picture at all. If you're not worried about the result, however, and are just looking to take good pictures, AF should suit you well, as long as you're aware of its limitations.'

Motor sports

Motor racing – whether cars or bikes – is the definitive high-speed, action-packed sport. A brief overview of this exciting branch of photography gets you started.

1 Viewpoint

When you arrive at a racetrack the first thing to decide is where you are going to shoot from. This is dictated, to some extent, by the shape of the circuit and the position of spectator areas.

Shooting down a long straight gives dramatic head-on pictures, whereas photographing across the track lets you include the crowd, or pit area, for an interesting background. Stand across from the finishing line if you want to grab pictures of the chequered flag greeting the winner.

Bends and chicanes are good vantage points – especially for spectacular shots of speeding motorcyclists as they lean their machines precariously into the tight curves.

Shooting low down from the racers' level exaggerates the bulk and power of the vehicles. A higher viewpoint cuts out distracting backgrounds for clutter-free compositions.

▼ *If you want to add a bit of variety to your pictures, try tilting the camera when you compose a shot. This gives the impression that the car or bike is racing down a steep camber, which heightens the sense of movement and speed.*

lens focusing

4 **5**

shutter speed

1 **2** **3**

viewpoint composition

3 Composition

For pictures with maximum impact, try filling the frame with a single bike or racing car. A close crop makes the most of the bright colours and shiny metalwork found on today's racing machines.

Looser framing includes more of the field. This is ideal if you want to capture action sequences – for example, one racer overtaking another, or a spectacular crash.

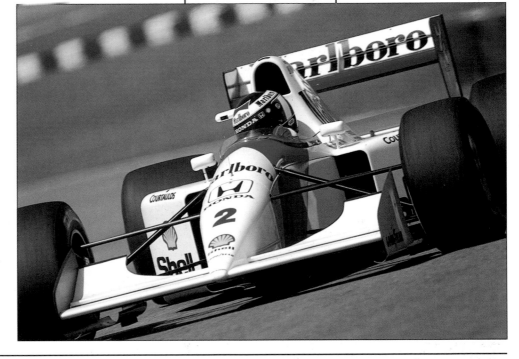

2 Shutter speed

With competitors whizzing around the circuit at speeds in excess of 300 km/h, fast shutter speeds are the order of the day if you want to freeze the action. Aim to set a shutter speed of at least 1/500th sec and use a monopod to add stability and reduce the risk of camera shake.

Drivers are forced to slow down as they navigate corners and chicanes, so you stand a better chance of grabbing a sharp picture at these points on the circuit.

In low light with slower shutter speeds, you are more likely to freeze a speeding subject if you shoot it head-on.

Panning is a useful technique that lets you use slower shutter speeds and still keep the subject sharp. On panned shots backgrounds are recorded as a blur, which helps to convey a sense of speed.

For a different approach, try using a shutter speed setting of 1/60th sec. The background remains in sharp focus, but the cars and motorcycles are recorded as attractive streaks of colour.

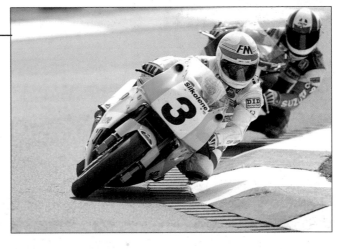

▲ *The bends and corners on a circuit offer plenty of potential for dramatic photographs of motorcyclists. Aim to take the picture as the riders lean their bikes over to sweep around the raised kerbstones.*

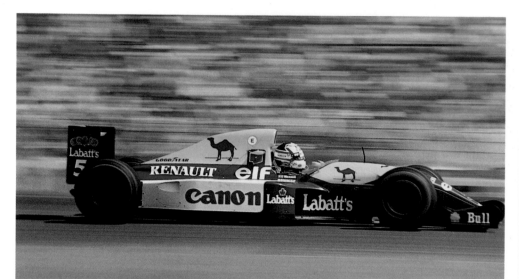

4 Lens

Unless you are able to obtain a trackside pass, you are likely to be a considerable distance from the action. This makes a telephoto the obvious lens choice.

A 300mm telephoto lets you isolate a single vehicle on most parts of the circuit. A 1.4X teleconverter increases the focal length of a 300mm lens to 420mm, allowing you to fill the frame with racers on more distant parts of the track.

Telephotos effectively compress perspective, so near and far subjects look as though they are bunched closer together than they

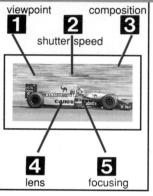

▲ *Panning conjures up a sense of speed by blurring the background, while keeping the subject sharp.*

really are. This adds to a shot's impact and heightens the feeling of action.

If you are limited to shorter focal lengths, concentrate on pictures showing several cars or bikes battling for position. A single vehicle tends to look lost in the frame when it is surrounded by lots of

empty space.

Fast lenses are best as they let you shoot on slow film for top quality pictures. The wide maximum aperture also means you can throw the background out of focus, to concentrate attention on the racers.

If you are lucky enough to gain access to the pit area, a wide angle zoom is a good choice. You can move in close to capture the action surrounding the cars, bikes and pit crews and still take in a view that's sharp from front to back.

5 Focusing

Racing cars and motorcycles travel so fast that it's difficult to focus on them.

Professional sports photographers follow-focus: they constantly change focus to keep the competitor sharp at all times. However, this is a particularly difficult technique to master.

An easier method is to pre-focus on a part of the track, and then fire the shutter *just before* the subject reaches that point. Firing early compensates for the slight time lag between pressing the shutter release

and the shutter firing.

Some advanced AF systems are able to keep up with a speeding car or motorcycle, even when it is

racing across the frame at top speed. This leaves you free to concentrate on composing the photograph and capturing the moment.

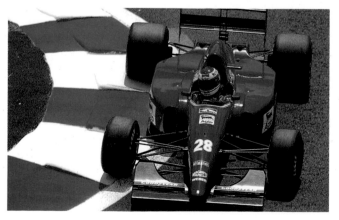

CHECK IT! ✔

Camera: an SLR is essential, because it accepts interchangeable telephoto lenses – even the longest lens setting on a zoom compact is too short for this type of photography.
Lenses: use 300mm and 600mm telephotos for pictures of racers on the circuit. A wide angle zoom is a good choice for shots in the pits.
Teleconverter: a 1.4X model extends your range of picture possibilities and only loses one stop of light.
Camera support: a monopod or tripod is essential when using a long telephoto lens.
Film: try to shoot on slow, or medium slow films – ISO 50 or ISO 100 – for maximum colour saturation and fine grain. Only switch to faster film when the sky is heavily overcast and you can't set fast shutter speeds.
Trackside passes: apply to the race organisers for a pass that will give you access to the trackside and pit areas. Alternatively, ask if you can visit the circuit during practice, when the spectator areas are less crowded.
Safety note: there are strict safety regulations surrounding any race meeting and it's in your interests to familiarize yourself with them. For example, you should never cross the track to change shooting positions during a race. Also, avoid using flash, as the sudden burst of light could distract a driver's attention with fatal consequences.

◄ *An alternative to a trackside viewpoint is to shoot from high up in the grandstand. Looking down on to the track lets you make the most of the sleek lines of modern racing cars.*

Simon Bruty – Capturing the moment

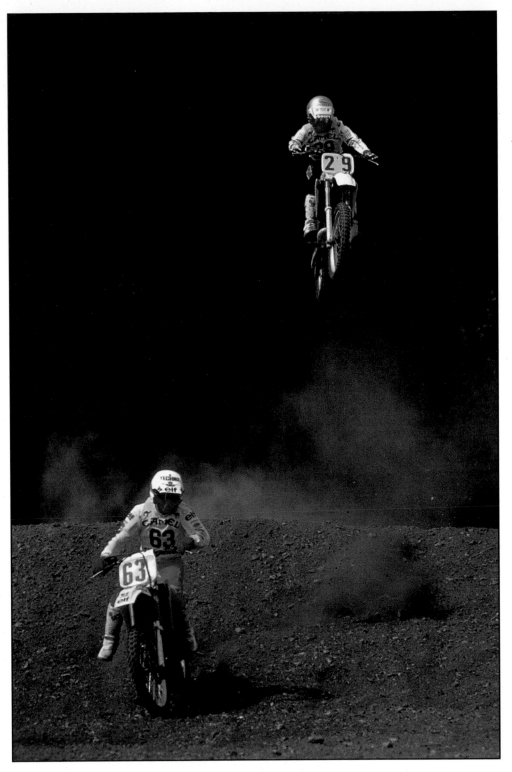

"This event was the 500cc Belgian Grand Prix. As the riders came out of the woods they had two jumps in succession. Some of the better ones were jumping as high as five or six metres. I think the picture works because the light is very good, and one rider has finished the jump while the other is still in the air, giving the photograph a dramatic feeling.

I was using a 300mm f2.8 lens extended to 420mm with a teleconverter. I needed a fast shutter speed of 1/500th sec to freeze the action."

Taking action pictures tests today's photographers and their cameras to the limit. Top sports photographer Simon Bruty's pictures are often captured with the kind of long telephoto lenses well out of reach of most amateurs, but his eye for timing is an inspiration to all.

As a teenager, Simon Bruty was interested in both photography and sport. His career in photography began when a kind cricketing coach put him in touch with the Allsport picture agency. During the next two years he worked his way up from being a darkroom technician to a fully fledged sports photographer, learning the ropes as he went. Throughout his apprenticeship in the darkroom Bruty never lost sight of his ambition to take pictures. At the beginning, however, he thought that becoming a professional photographer was

"I shot this around an outdoor practice pool. It was raised, so you could see the water surface at eye level. I knew I would get something out of it because of the backlighting. It was late afternoon and the sun was going down behind the stand that you can just see behind the swimmer.

I stayed for about 20 minutes until the stand was completely in shadow, but the sun shone into the pool. Every time this swimmer came past I took three or four shots. I knew there was a picture there – it was just a question of getting the right moment."

Technical details

'I used a Canon T90 with a 400mm f2.8 lens. It gave me a shutter speed of 1/2000th sec, which froze the action. With a backlit picture of water you can easily overexpose. I always judge the exposure with the help of a Minolta Meter IV – I rarely trust the built-in camera meter.'

'against the odds'.

In his spare time he photographed local sports events, like motocross and cross country running, where access to the action isn't restricted only to established photographers. Back at the agency the other photographers would go through the results with him, offering some valuable advice and encouragement for the future.

Technical grounding

Looking back on his early career, Bruty can see the great value of his years as a technician. 'Many photographers regret that they never had a darkroom training. It gave me a good technical grounding and taught me to know how much exposure latitude you can get from particular films.'

Working in the darkroom gave Bruty an eye for a

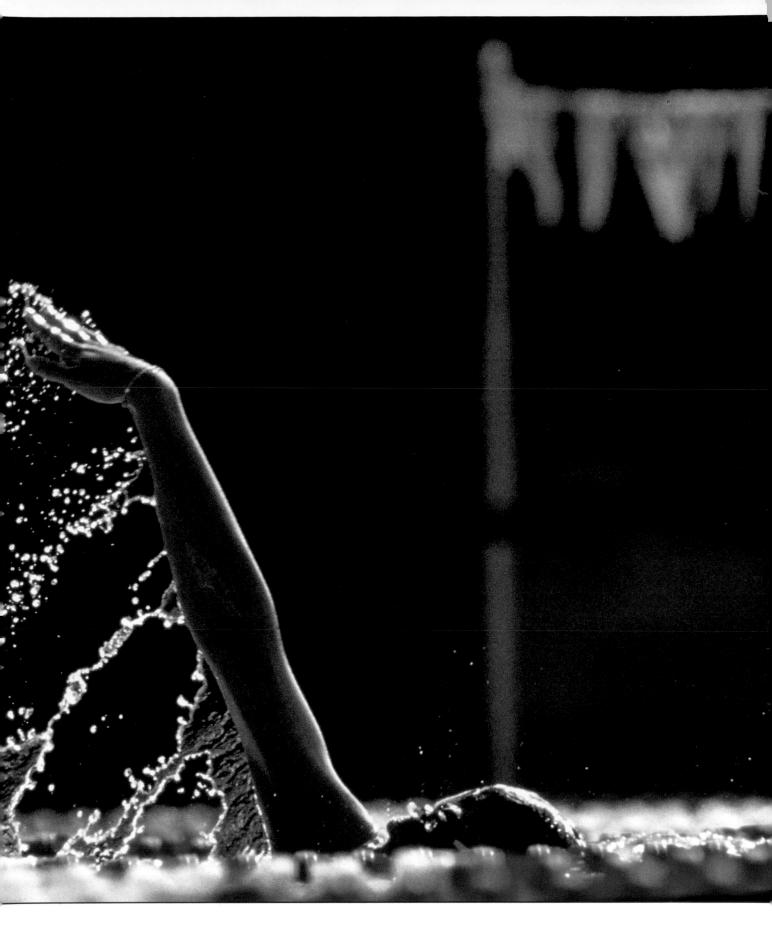

good picture. After processing a photographer's film he would watch carefully which of the frames were chosen and learn what made a good image.

He believes that understanding sport can be helpful in gathering sports pictures, but it can also get in the way. He says that German magazines 'are keen on non sports photographers because they can be trusted to find a fresh angle. And they do.' It's competition like this that keeps Bruty on his toes.

Bruty always uses Canon equipment because of its advanced technology. He finds Fujichrome 100 film very versatile – though light levels dictate ISO speed. He normally packs the following gear into his gadget bag: 400, 300, 80-200, 28-80, 20-35 and 15mm lenses plus two converters and three camera bodies (in case one breaks down).

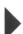 *"This is a photo of Peter Shilton, England's goalkeeper during the 1990 World Cup. I was positioned on the sidelines looking for an unusual shot, and thought it would make a good picture if I could shoot him through the net."*

Bruty uses two bodies for football and rugby, each fitted with a different lens. A 400mm is ideal for tight action shots on the field, while the wider 80-200mm zoom is used for covering action around the goal area.

"I used a Canon F1 with a 400mm f2.8 lens. The exposure was 1/500th sec at f5.6."

Technical details

'This picture of Shilton was shot on Fujicolor ISO 800 negative film which gives better results in low light conditions than my favourite Fujichrome ISO 100 slide film. That film would have been too slow to catch the moment when Shilton drank from the bottle.'

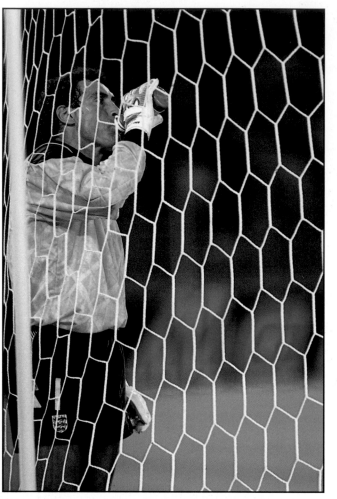

"This is Nelson Piquet at the 1990 Hungarian Grand Prix. I was stationed in the pits. Although the image is a cliché, the framing makes it special. The eyes make the picture powerful – just what I was looking for. The lighting is very poor where the mechanics work, so you need fast lenses."

Taken with a 200mm f2.8 lens at 1/60th sec.

"This is Christian Sarron during the 1989 Donnington Motorbike Grand Prix. This picture is the most dramatic one of a sequence of frames showing the accident. It was the only one in which the rider's body fitted the frame perfectly.

As I was panning with him from the top of the bend the bike slipped away and he went with it. He stayed on the same plane throughout the action."

Taken on a Canon F1 with a 300mm f2.8 lens at 1/250th sec with an aperture of f6.5.

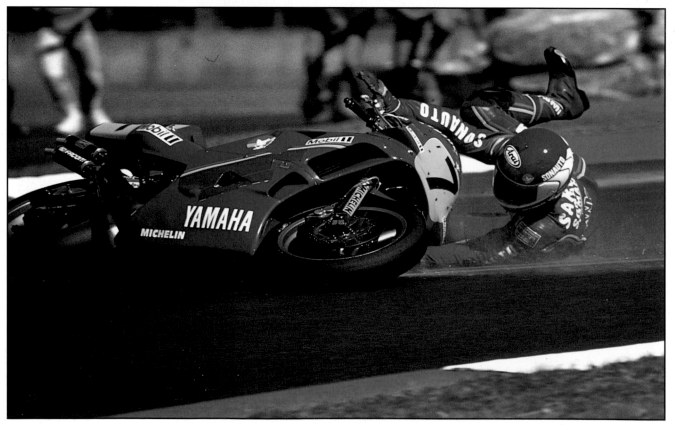

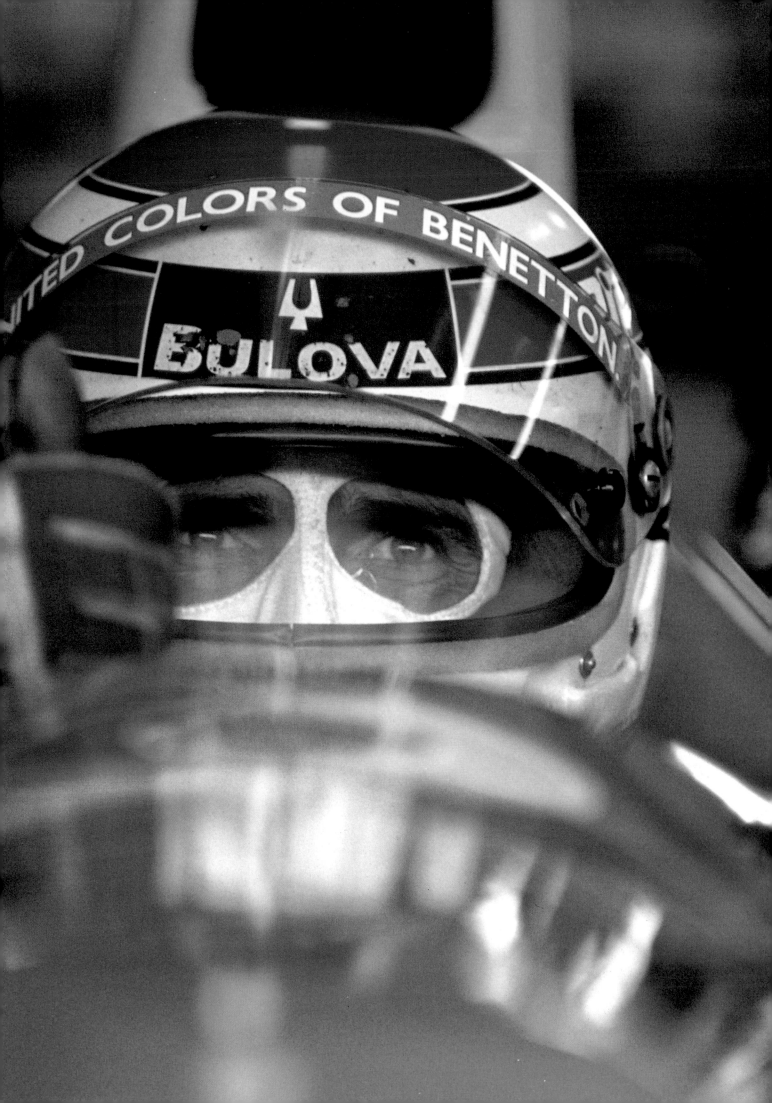

"This was a lucky picture – a one in a million shot that happens when things are out of your control. It was Cambridge University Rugby Team against Doshisha University from Japan. The players were stretching for the ball at a line out. It happened and I was there.

With a rugby match I keep my equipment to a minimum because you're running up and down. The more you carry, the harder work it becomes. Normally I like to use two camera bodies, one with a short lens."

Shot with a 400mm f2.8 lens on a Canon F1, at 1/500th sec with the aperture at its widest.

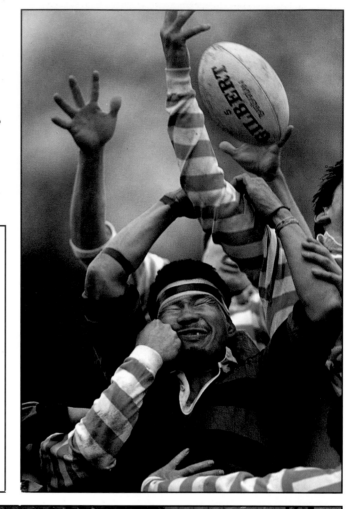

"I took this at an outdoor pool during the 1989 European Swimming Championships in Bonn. I was one of a hundred photographers at the side of the pool roped off toward the finish line. I'm always looking for something unusual – and that's difficult because sports have been covered by photographers for over half a century. It was one of those times when the water was very calm. I saw the swimmer's shadow on the surface of the water and this is the result."

Taken on a Canon F1 with a 400mm f2.8 lens.

Technical details

'Because it was a dull day, and I was using ISO 100 Fujichrome, I had to choose a fairly wide aperture of f5.6 to make the right exposure and use the advantage of a high shutter speed – 1/500th sec in this case. You shouldn't use shutter speeds below 1/500th sec with such a long focal length lens because camera shake is more likely.'

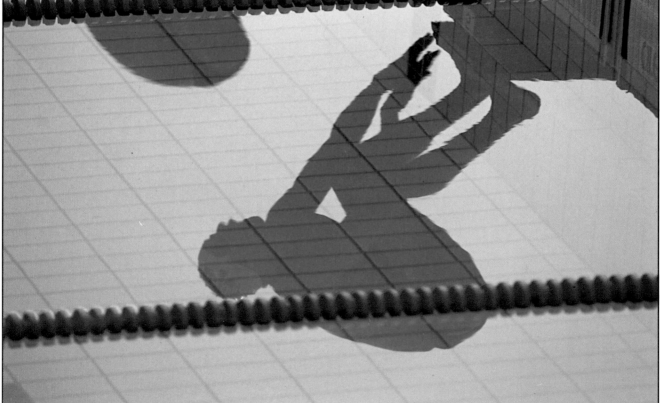

Indoor sports

With a little preparation, you can capture the competitive nature of indoor sports events.

1 Viewpoint

Try to be as near to the action as possible. Ask in advance if you can position yourself on the sidelines, so that you can move up and down according to where the action is. Otherwise, sit at the front.

If you're photographing hazardous sports like squash or ice hockey, you'll probably find there's a protective glass or perspex screen between you and the action.

Either press your camera lens right up to the screen so that it's touching it before you start to shoot, or – if the screen is dirty or scratched – shoot from above the screen.

2 Lighting

Flash is likely to be banned during matches. In any case, it won't illuminate all the players in team sports unless you are within two or three metres of them.

If you do want to use flash, choose a sport like boxing where you can get very close to the action, and photograph at a training session.

When shooting by available light, you have no control over the type of illumination used. If possible, visit the venue in advance to see how high the light level is, and whether the lighting is tungsten or fluorescent.

As a guide, squash courts often have fluorescent strip lighting. To avoid a greenish colour cast on your pictures, fit a CC30 magenta or fluorescent-to-daylight filter (or a CC30 red if you're using tungsten film).

General sports halls often have tungsten lighting. In this case, fit an 80A filter – or use tungsten balanced film – to avoid an orange cast.

If there are television lights at the match, you can use daylight balanced film without filters.

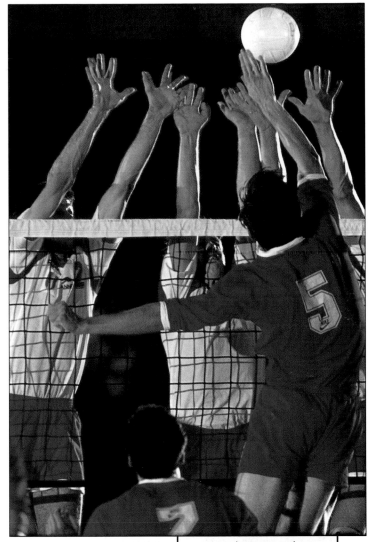

► *In volleyball, have your camera ready when the ball is passed near the net for the chance of photogenic action – as in this tightly cropped picture.*

▼ *The photographer positioned himself near the goal area to capture action packed shots.*

3 Composition

Try to leave a little space around the main subject, especially with fast moving sports like volleyball. That way you can avoid cutting the ball out of the frame or missing a player's long reach for the ball.

A zoom lens lets you take a variety of shots – use its telephoto end to capture facial expressions. A long focal length is also handy for closing in on details to create more unusual shots in gymnastics, for example.

If you aren't very familiar with the sport you're photographing, it's a good idea to spend some time watching the play before you shoot. That way you will be able to gauge the pace, and work out

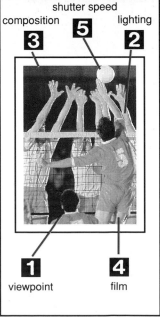

shutter speed
composition lighting
3 **5** **2**

1 **4**
viewpoint film

where the most exciting action will be. For example, in ice hockey this is around the goal area.

4 Film

Shooting on black and white film avoids problems with colour casts, especially when you're unsure what light source will be used. Alternatively, bring along a selection of film – say, black and white, daylight and tungsten balanced. Load up with the appropriate one.

If you're not using flash, take a fast film with you to cope with low light levels – at least ISO 400.

You could push slide or black and white print film by 1 or 2 stops – but bear in mind that it will show more grain and extra contrast. *Don't* push colour print film unless it's specially designed for push processing.

▶ *This unusual image was captured with a telephoto lens, which cut out all unwanted details from the frame. The black background provides a good contrast to the spotlit subject.*

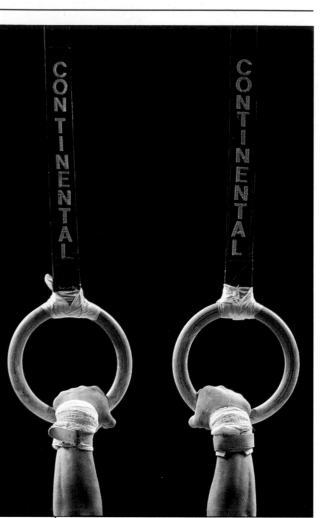

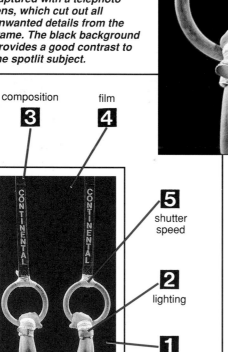

composition **3** film **4**

5 shutter speed

2 lighting

1 viewpoint

CHECK IT! ✔

Camera: SLR.
Lens: a zoom of either 35-80mm or 70-210mm, depending on the sport and how far away you are from the action.
Film: fast film – either push ISO 400 slide film by 1 or 2 stops, or load up with ISO 1000 or 1600. (Do *not* push colour print film.) Tungsten balanced film with tungsten lighting to avoid colour casts – or use black and white.
Filters: With daylight balanced film and tungsten lighting, an 80A; with fluorescent lighting, a CC30 magenta or FL filter – or a CC30 red filter if you use tungsten film.
Camera support: a monopod is essential if you can't use fast shutter speeds with long lenses.
Location: school, gym, sports centre.
Safety note: if you are close to the action, be sure to keep out of the way of the players and referees.

5 Shutter speed

To freeze action, fast paced sports like ice hockey or badminton demand a shutter speed of at least 1/500th sec.

You can get away with a slower shutter speed – say, 1/125th sec – if you're photographing a balance in gymnastics or an indoor tennis player poised to serve, for instance.

To avoid camera shake, bring a monopod if you intend to take this kind of shot with a telephoto lens, and use as fast a shutter speed as possible.

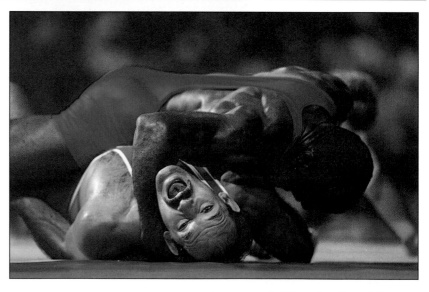

▲ *When shooting a fall or submission, try to shoot at the competitor's eye level to capture his expression. You'll find that this is easier when the action takes place in a raised up ring.*

Photographing sport indoors

Capturing a fast-moving team sport is difficult enough outdoors, but under artificial lights the photographer has even less margin for error. Frank Coppi shows David Jones how to cope with the difficulties of indoor basketball.

We arrived at this midweek basketball game between English teams Hemel Hempstead and Leicester City hoping that there wouldn't be a big crowd. The more empty space there is in the stands, the greater the scope photographers have for varying their viewpoints. However, unfortunately for us the hall was packed with faithful supporters so we had to manage on the sidelines as best we could.

At least the lighting was bright enough to give us a sporting chance. Frank Coppi's lightmeter told us that we could get away with a shutter speed of 1/500th sec if we opened the aperture right up to f2.8. The fast shutter speed is essential if you want to avoid blurred action shots, and the wide aperture ensures that enough light is hitting the film. But it also reduces depth of field to the bare minimum, leaving you with a very narrow band of sharp focus.

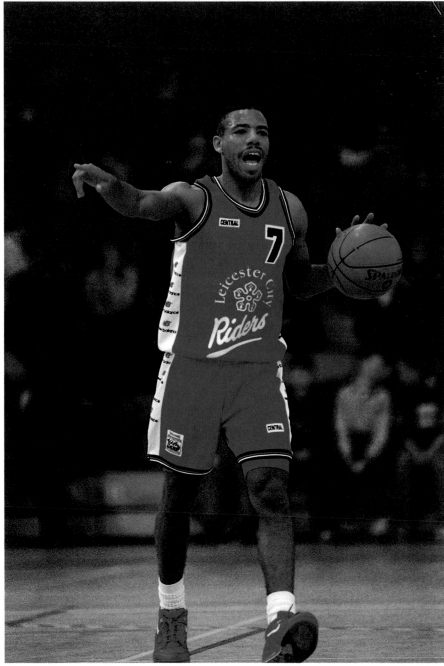

▲ *Basketball gives the photographer great scope for variety. Frank took this unusual picture from the sidelines using a 300mm lens. As the Leicester player prepares to attack, the ball looks as though it's stuck to his hand.*

The set up

Frank and David were photographing a league game between Leicester and Hemel Hempstead. As all the stands were packed, they were only able to shoot from one of the sidelines and the areas immediately behind the baskets. The hall was lit by harsh overhead lights.

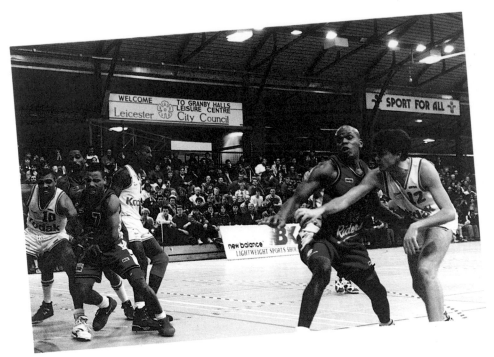

Chasing the play

We were both shooting on Fuji ISO 400 colour print film rated at ISO 1600 – only by pushing the film two stops in development like this would we stand any chance of getting decent exposures. I used a Nikon F3 and alternated between 200mm and 50mm lenses. Having found a vantage point near one of the baskets, I chose the 200mm lens and waited for play to begin.

When the game started I was totally bewildered by the speed of play from one end of the court to the other. At first I tried to follow the ball around, but focusing manually on the constantly moving players proved impossible, and the added weight of the 200mm lens made the

▲ *David crouched down in the corner of the court to take this exciting action shot with a 50mm lens. There's plenty of movement in the frame, but none of the players are quite in focus, and only part of the ball is visible. The background detail is an added distraction.*

▼ *David pressed the shutter release button at just the right moment to catch the Leicester player's leap for the basket. David stuck with the more manageable 50mm lens for this picture, but the shot would have looked better on a more powerful lens, and a crowd looks less distracting when thrown completely out of focus.*

LOOKING FOR ACTION

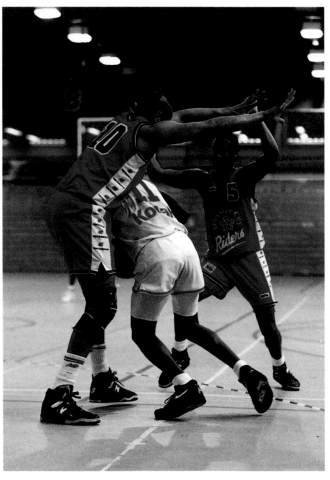

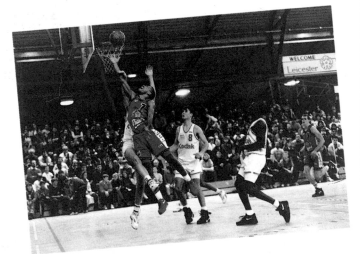

Tip Pushing print film

Pushing slide film is always possible, but only certain types of print film are suitable. Both Fuji and Kodak make print films that can be pushed. This is invaluable for newspaper sports photographers like Frank who have to work on print film but often end up shooting in low artificial light. By treating ISO 400 film as ISO 1600, Frank was able to use the faster shutter speeds needed to capture action. The subsequent underexposure was corrected during development. Not all labs will push film – you may have to find a specialist one.

1 BEATING THE DEFENCE
Frank Coppi used an 85mm lens to take this amusing shot of a Hemel Hempstead player bursting through the Leicester defence on his way to the basket. It's a dramatic picture, but it's slightly spoilt by the fact that two of the players' faces are totally hidden from the camera.

F3 very unwieldy without a tripod.

So I decided to switch to the 50mm lens and concentrate on one end of the court. By focusing on the basket and then waiting for the players to arrive I was able to take some reasonably good action shots. But the 50mm lens left the players looking quite small in the frame, and I also found it hard to know when to press the shutter.

Varying the viewpoint

Frank was also using an F3 but he chose a wider range of lenses. With 300mm, 135mm, 85mm and 50mm lenses at his disposal, he knew he had the focal range to work in any part of the hall. Instead of finding one spot to work from and sticking to it, Frank moved around the court experimenting with different vantage points. He worked at both ends, behind the baskets and on the midfield sideline.

He's covered basketball many times before, and was looking for something more than the usual shots of players putting the ball in the basket. He started by concentrating on the midfield action. Using a 300mm lens, he stood on the sidelines and took some exciting full frame shots of individual players running with the ball and evading defenders. A monopod helped him keep the heavy lens steady.

Experience counts

Frank then moved down to the basket, switched to a 135mm lens and took a series of shots of players leap-ing upwards and struggling for the ball. One of his most effective pictures, however, didn't involve any court action at all. At the end of the game, when he was sure he'd covered enough of the on-court action, he squatted down behind the Leicester team bench and took a great shot of a tired player taking a rest.

'Basketball is a difficult game to cover', says Frank. 'The play moves around so quickly that a beginner can easily get discouraged. If you're covering a fast indoor sport for the first time, don't be afraid to use a lot of film – you're more likely to get something good that way. But the more you shoot a sport, the better you'll get at judging where the best viewpoint is and when to start taking pictures. Experience definitely counts.'

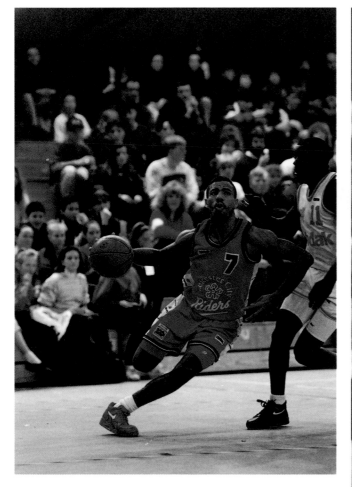

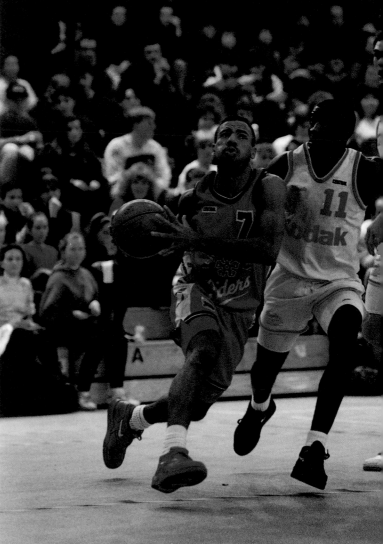

2 RUNNING WITH THE BALL
These are the sort of dynamic midfield shots that David was unable to take. Frank focused a 135mm lens just in time to catch this excellent running sequence. The shots show the Leicester attacker's speed and power, and the crowd is blurred enough not to be distracting.

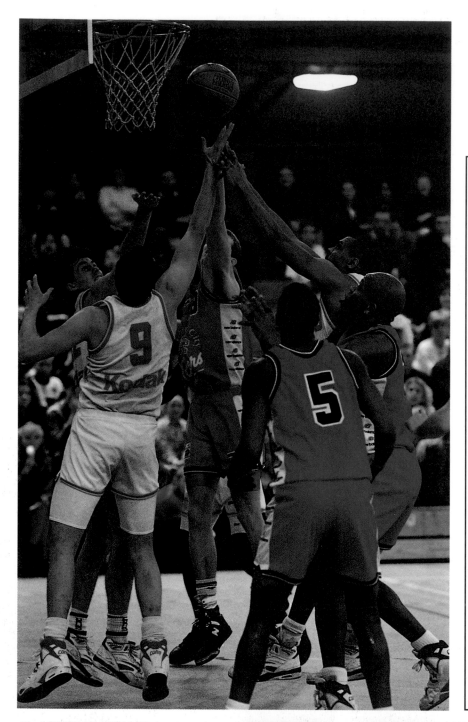

Compact tips

❏ If you're using a compact in this sort of situation a zoom facility is essential. Otherwise you'll have to stay on the sidelines near the basket and hope the play comes close enough to give you a shot where the players fill the frame.

❏ On many compacts flash is automatic and can't be turned off. Check before using cameras like this: the light can be at best distracting, and at worst may cause temporary blind spots.

SLR tips

❏ If you own an advanced SLR you'll find that the autofocus facility is invaluable when photographing fast moving sports like basketball. The camera refocuses on a player so quickly that you'll be able to follow the ball all over the court and shoot whenever an opportunity arises.

❏ If you're focusing manually, try prefocusing on the basket and waiting for the action to arrive as Frank did. A monopod makes manually focusing a big lens far easier.

3 ACTION IN THE AIR

Frank prefocused on the basket when he saw that play was heading in that direction. So he was well prepared to take a balanced picture of this desperate six man struggle for the ball. It's an excellent example of composing at speed – he's even managed to keep the basket in frame.

▶ *As the game was coming to an end, Frank noticed this tired Leicester player relaxing on the bench. So he crept as near as he could, crouched down behind him and started shooting with an 85mm lens. As you can see, the player soon spotted him, but his baleful eye makes the photograph even stronger.*

Photographing swimming indoors

Swimming is not an easy sport to photograph at the best of times, but indoors there's the added problem of variable light. Frank Coppi shows David Jones how to rise to the challenge.

When we arrived at Crystal Palace in south London for this open swimming meet, the morning sky was completely clear and the sun was beaming down. As there were a lot of windows at either end of the building that housed the pool, I imagined this brightness would be an advantage to us. But it turned out to be a mixed blessing.

Once we were inside, Frank got as close as he could to the water and took a reading on his light meter. Parts of the pool were very brightly lit but others were in deep shadow, and this made working out a correct exposure very difficult indeed. All we could do was take the meter at its word and hope for the best.

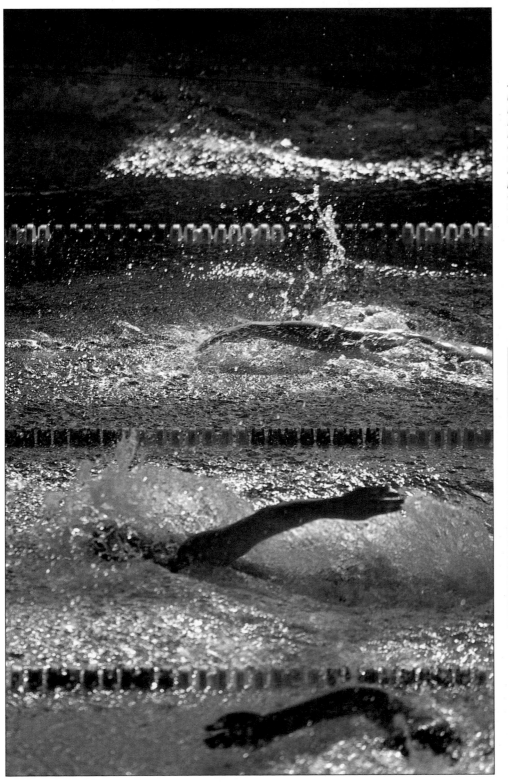

◄ *Shooting across the pool during a freestyle race, Frank made great use of the uneven lighting conditions. The bright sunlight has picked out the flying splashes of water, which stand out against the shadows in the pool behind. The semi-silhouetted arms in the foreground make the shot all the more dramatic.*

The set up

Frank and David were shooting a swimming tournament in a 50 metre indoor swimming pool. The building was lit from above by electric strip lights and by natural light through windows at either end. In the morning the sun shone brightly through the east facing window, but the light was more even when it disappeared above the building later in the day.

A lack of timing

When the races started I loaded a film and began shooting. I was using a Nikon F801 with a 150mm lens and Fuji ISO 100 slide film. I started by trying to get a wide shot across the pool of a backstroke race. Because the light was so variable the best exposure I could get was 1/500th at f2.8. This gave me a very narrow band of focus, and meant that only the swimmer in the middle of the frame was in focus.

When the breaststroke heats began I crouched at the top of a lane and tried to take a front on close-up of one of the swimmers. But my aperture was still wide open and focusing proved very hard. I just didn't have enough time to take a sharp shot of the fast moving figure, and water reflections were another problem.

Coping with the conditions

Frank used a Nikon F4 with a 180mm lens and Fuji ISO 100 colour slide film. He wanted to begin by photographing the start of a race. But in such poor light he couldn't afford the depth of field required to get all the lanes in

BEATING BAD LIGHT

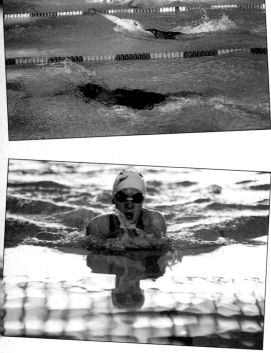

▲ In his first shot David was trying to capture the competitive atmosphere of a close race. But because the light was so low his aperture was wide open, leaving only the swimmer in the middle of the frame in sharp focus. When he moved down to the western end of the pool to photograph the breaststroke heats, he found the light very uneven. Focusing was also a big problem, especially as he was using a manual lens. In most of his shots the swimmer was either out of focus or gone by the time he pressed the shutter release.

1 ▲ THE START
Frank began by photographing the start of a backstroke race. But with the camera's aperture wide open he couldn't get all the swimmers sharply in focus, so he decided to try a slow exposure instead. At a shutter speed of 1/4 of a second the moving swimmers became blurred and created a very effective action picture.

2 ▼ FREESTYLE
To photograph the freestyle events Frank moved to the side of the pool and got down as low as he could. He then focused on a particular lane and waited for the swimmer to arrive. He'd noticed that this girl was breathing to the right (towards the camera) every two strokes, so he timed his shot to try and include her face.

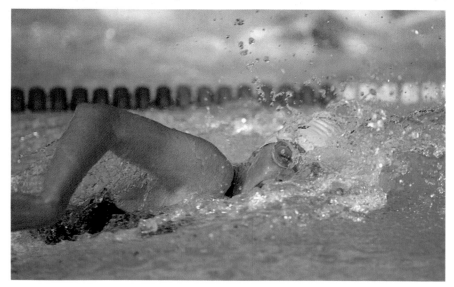

focus. He solved this problem by shooting on a long exposure to get a deliberately blurred effect that removed the need for sharpness and produced an extremely effective action picture. He then decided that he would turn his attention to individual swimmers.

He noticed that the middle lanes were more evenly lit than the outside ones, so he concentrated on the swimmers in them. The first races he photographed were backstroke and front crawl. 'A side-on view is essential for both these strokes', says Frank, 'because you can only see the swimmer's face from that angle. You have to time your shot so the arm doesn't obscure the face, and with crawl you've got to catch the swimmer as his head emerges to breathe.'

Focusing in advance

For the breaststroke and butterfly events Frank found a good viewpoint at the end of a lane, switched to a 300mm lens and used a monopod to keep it and the camera steady. To overcome his focusing problems he prefocused on the lane ropes and waited for the swimmer to race into focus. He finished with a dramatic close-up of a swimmer's face.

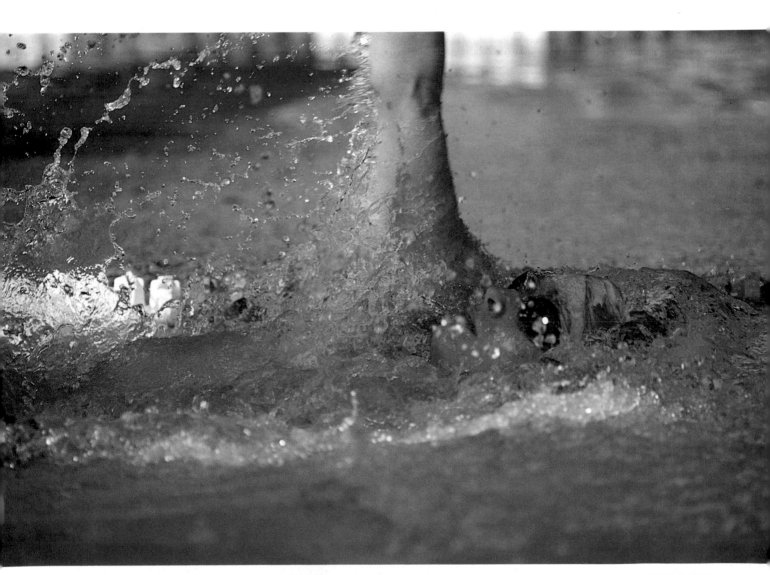

3 ▲ **BACKSTROKE**
This shot of a backstroke heat was also taken from a low side-on viewpoint. Getting a clear view of the face was again quite tricky, so Frank made sure the left arm wasn't in the way before shooting. He used a 300mm lens to close right in on the swimmer and pick up the detail in the splashing water.

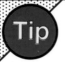 **Tip** ## Using faster film

'We were relatively lucky with our light on this shoot', says Frank. 'In most indoor pools it's even worse. So it's worth bringing some fast film with you in case you end up grabbing for light. We brought ISO 400 film with us, knowing that if the pool area was really dark we could always push it a stop or two.

'Be prepared to shoot lots of film when you're covering indoor swimming. With focusing so difficult, there are bound to be a lot of wasted frames for every good one.'

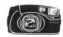
Compact tip

All-weather compact cameras are perfect for poolside photography. They are completely waterproof under normal circumstances, so you can position them much closer to the water than you would dare with a conventional camera without having to worry about splashes. This should give you more chance of getting dramatic action pictures.

SLR tip

If your autofocus camera has a focus priority mode, you should be able to use it to capture swimmers as they reach a particular point in the pool. Once set up, the camera is triggered when a moving subject enters the frame. But take care – waves and splashing water can sometimes trigger the shutter prematurely.

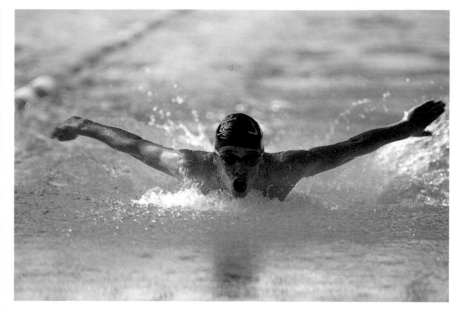

4 ▲ BUTTERFLY
Butterfly swimmers move through the water very quickly so focusing on them isn't easy. Crouching at the western end of the pool, Frank chose a brightly lit part of the lane, prefocused on the dividing rope, then pulled back into the middle of the lane and waited for the swimmer to move into focus.

5 ▼ BREASTSTROKE
Frank wanted to finish off with a strong close-up of a swimmer's face, and the best stroke for this is breaststroke. Using his 300mm lens, he waited for this swimmer to pull her head out of the water and then pressed the shutter. It was hard to get the timing right but he ended up with a wonderful shot.

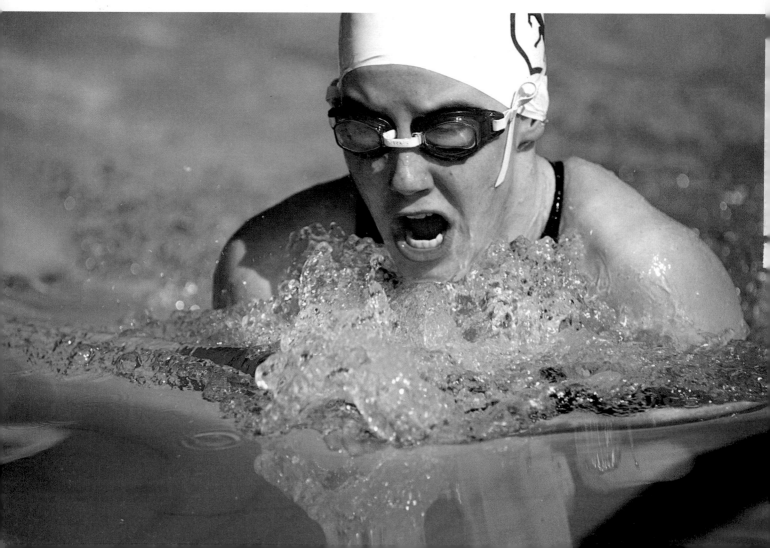

Kos Evans – Sport on the water

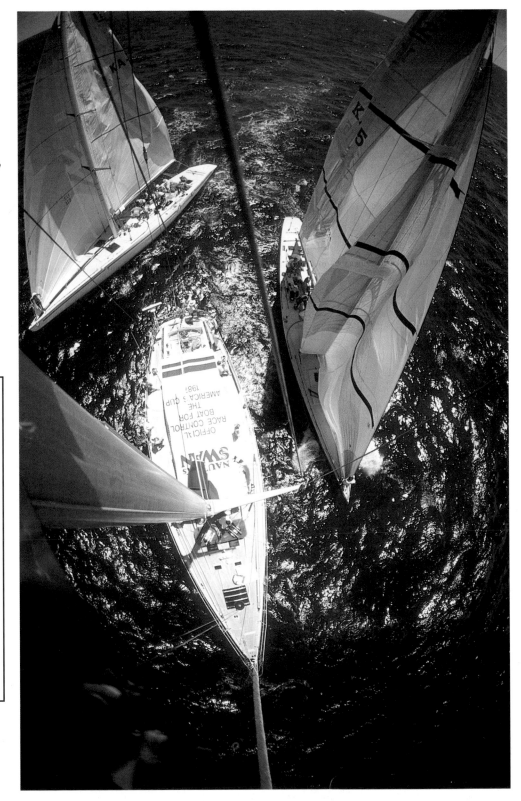

"This was taken from up the mast of the start boat at the beginning of a big race in Australia. The two boats were jostling for the best position and the crew hoisted me up just in time to catch the action. I had to cover my bright oilskins on the way up so the boats didn't think I was the starting flag!" Taken on an Olympus OM4 with a 16mm fisheye lens on Kodachrome 64 at 1/250th sec and f11.

Technical details

'I was lucky to get this shot. The two boats came to the start at the last minute, so I was winched up in a hurry. When I reached the top I immediately realised that even with a 24mm lens I wouldn't be able to get all the boats in. So I switched to the 16mm fisheye lens, which wasn't easy up there. The fisheye allowed me to include everything in the frame, but I had to be careful to avoid getting my feet in as well.'

With an imaginative eye and an ability to work in the most precarious conditions, Kos Evans has produced a range of spectacular images that bring the dramatic world of yachting to life.

Koren 'Kos' Evans made her name in yachting photography during the 1982/83 Americas Cup race. In an effort to get a more unusual view of the British challenger, *The Victory*, she was hoisted up the 75ft (23m) mast to the bosun's chair. She shot downwards using the widest lens she had, and the resulting pictures were widely acclaimed.

Mast shots have since become something of a trademark, but Koren is a versatile photographer and uses a

▶

"They hold this classic yachts event every September in St Tropez. It's great from a photographic point of view because at that time of year the Mistral wind brings big storms towards the coast, and the old boats look perfect in those conditions. This was taken on a very rough day, with waves running down the deck of the boat I was on. I used a tobacco filter to give the shot a sepia feel."
Taken on a Canon EOS 1 with a 28-80mm zoom on Fuji ISO 100 slide film at 1/250th sec and f5.6.

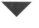

"I spent about nine months working with the British Americas Cup team a few years ago, and photographed everything they did. This picture was taken on a practice day. Conditions were very stormy, but there was a lovely silvery light on the sea, and the crew were wearing silver and white outfits that blended in nicely. I shot from behind the wheel to get a strong shape at the front of the frame."
Taken on an Olympus OM4 with a 28mm lens on Fuji ISO 100 slide film at 1/125th and f11.

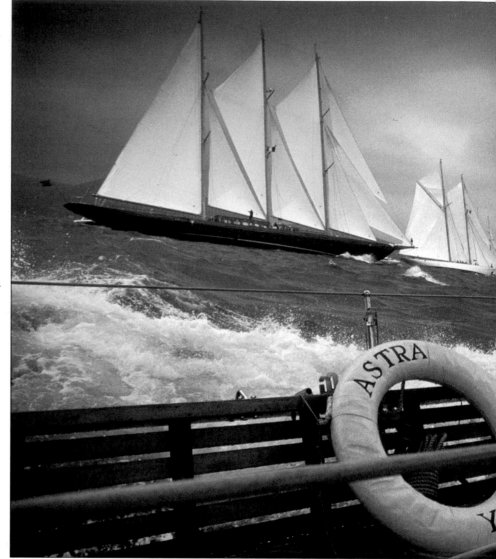

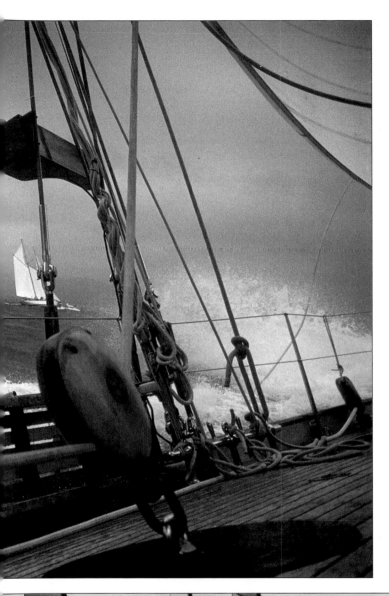

wide variety of viewpoints to get the pictures she wants. 'When I'm covering races', she explains, 'I hire a press launch and follow the boats, but whether you get the shots or not depends largely on how good the driver is. If you're not in the right place at the right time you haven't a hope.' She also uses a rubber raft to get low viewpoint shots during a race.

Near misses

'I'm still regularly asked to go up the mast', says Koren, 'but I do it less and less these days, because it's a bit risky and I've had a few near misses.' On one occasion a light boat overturned while she was strapped to the mast, and she only escaped when a quick-thinking sailor released the rope that was holding her.

But she admits that she enjoys working with an element of danger. She frequently shoots harnessed to the outside of a helicopter, and has even tried working from a microlite (a motorized hang glider). 'That was great fun', she says, 'but the pilot had to tell me to stop swinging around so much when taking photographs because I was altering the microlite's balance and endangering us both!'

Caring for equipment

Surprisingly, Koren has only lost five cameras over the past ten years, and that's been mostly due to gradual corrosion rather than actually dropping them in the sea. 'The atmosphere I work in is so salty that no matter how waterproof the cameras are, they tend to get corroded in the end. But you can delay the decay if you look after them. I used to use Olympus OM4s, but I've switched to Canon EOS 1s now, and after every sea shoot I clean them thoroughly with surgical spirit, which removes all the salt. I dropped a camera recently while climbing a mast, which didn't do it much good. I'm lucky it didn't hit anyone!'

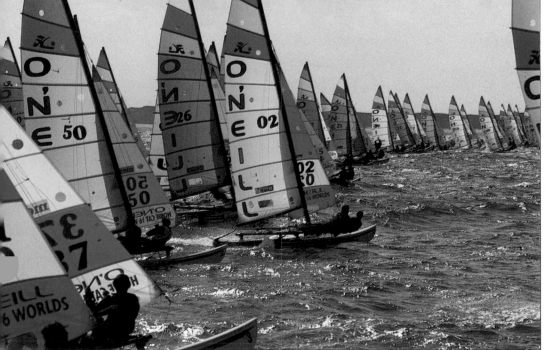

◀

"I took this shot from the deck of the start boat at the beginning of a race in Holland. These are very small yachts, and because the boat I was on was much bigger I was able to shoot from above them. The starting line is a good place for photographs because there's always something going on."
Taken on an Olympus OM4 with a 35-105mm lens on Kodachrome 64 at 1/1000th sec and f5.6.

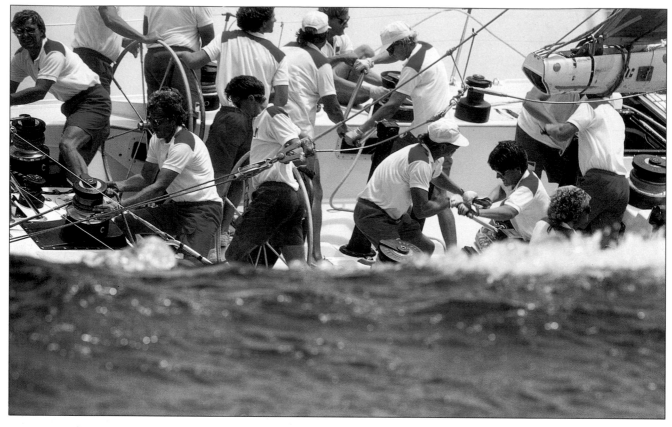

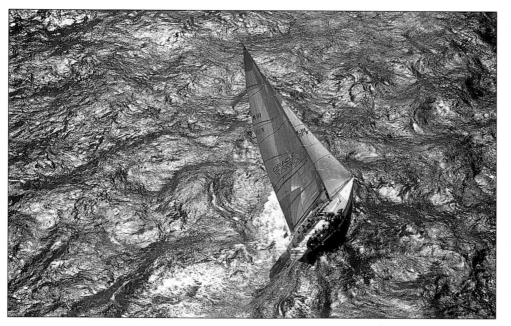

"I often use a small rubber boat to take shots from a low angle that give you more of a feel of what it's like to be at sea. For this shot I waited until my boat went down into a dip so there was a big wave between me and the yacht and it looked like the crew were almost in the water. I crouched down to get an even lower angle."
Taken on an EOS 1 with a 300mm lens on Fuji ISO 100 slide film at 1/1000th sec and f2.8.

You can do it

If you want to experiment with yachting photography, a vantage point in a small boat or dinghy is a good place to start. You can get some very dramatic views of yachts and other boats by shooting from below them.

You should hire a waterproof housing to protect your camera, or else use a disposable one. Wear a life-jacket, don't go out in a boat without someone who knows what they're doing and be careful not to get in the way of larger boats.

"As you may have guessed, I took this shot from a helicopter. It was a very windy day, and from high up you could see all the patterns the sun was picking out on the sea. I was in a harness so I could actually sit outside the helicopter if I wanted, which gave me much more freedom. You can't shoot slower than 1/500th sec in a helicopter because of the shake."
Taken on a Canon EOS 1 with an 80-200mm lens on Fuji ISO 100 slide film at 1/1000th sec and f8.

Athletics

Whether you want to shoot sportsmen and women in action or capture their facial expressions, an athletics meet offers you plenty of opportunities.

1 Lens

The focal length you choose all depends on your viewpoint and what kind of shots you want to take.

A frame filling picture of a high jumper might demand a 400mm lens or longer, but you don't necessarily need such expensive equipment. For example, the figures at the start of a race might appear small in the frame, but their combined effect is electric.

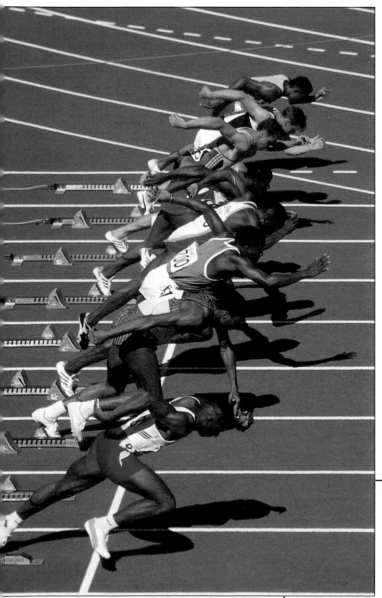

▲ Quick reflexes allowed the photographer to capture these sprinters just as they set off from the starting blocks.

2 Timing

In sports photography, shooting at the right moment so your subject is sharp is vital for successful pictures, and athletics is no exception.

Rather than trying to follow runners around the track with your lens, pre-focus on a particular point and wait for the athletes to reach it.

For example, this could be a line on the race track or where an official is standing. The finish line is an obvious place to train your lens on.

Why not have a go at photographing the runners at the start line, too? Choose sprinters rather than longer distance runners, because their pose at the start is more dramatic. Catch them with one foot off the ground.

In the field events, vary the moment that you release the shutter. For example, photograph the moment when the javelin leaves the competitor's hand, and also when it has travelled a few metres through the air.

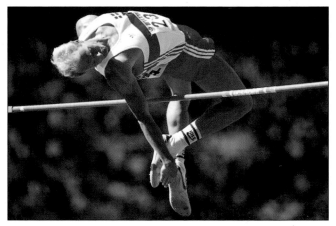

▲ Adjusting exposure for the sunlit parts of this high jumper's body means that the crowd behind him is dark and doesn't distract from the subject.

3 Planning

It's a wise idea to become acquainted with the sport, and study the action so that you'll know which aspects of it will make the best pictures. If you can, find out in advance which athletes are competing, and study their form so you know who to watch.

Visit the stadium beforehand if possible so you can find out the best angles from which to shoot. At smaller meets, it's worth trying to obtain a track pass.

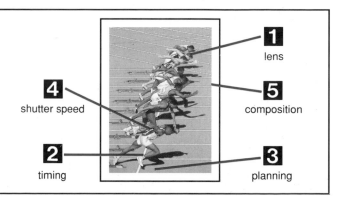

1 lens
5 composition
4 shutter speed
2 timing
3 planning

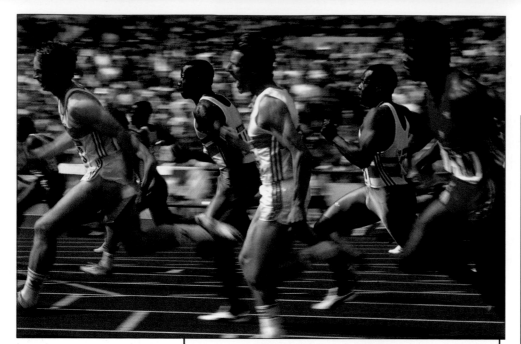

CHECK IT! ✔

Camera: SLR.
Lens: depends on where you are positioned and what shots you want.
Film: ISO 100 in good light; ISO 400 in poor light so you can use a workable shutter speed.
Camera support: a monopod is recommended – it's essential with long lenses.
Filter: not necessary.
Weather: bright lighting conditions give you more choice of shutter speeds.
Safety note: if you're lucky enough to be given a trackside pass, make sure you only go where directed by officials. Do *not* venture on to the track while a race is in progress, and be careful where you stand if photographing the throwing events.

4 Shutter speed

Altering the shutter speed you use has a profound effect on the image of athletes, especially if you compare this sport to, say, skiing.

Whereas all parts of a downhill skier's body move at about the same speed, this is not true of a runner. A speed of 1/60th sec might freeze a sprinter's body and head, yet record the faster moving legs and arms as an attractive blur.

Experiment with a range of shutter speeds – slow for an impression of movement, and faster if you want to freeze action.

5 Composition

The expression on competitors' faces is a subject in itself. Try capturing the look on the winner's face just as they cross the finish line and realize that they've won.

You could photograph the runner up embracing the winner after the event, or the strain on the face of a shot putter or long jumper. A zoom lens lets you close in on faces and then return to a wider view.

As most trackside sports are very fast moving, leave space around your subject so that they don't move out of the frame before you've taken the picture.

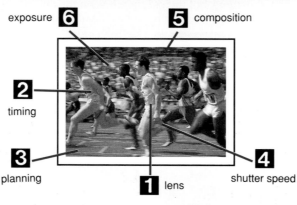

exposure **6** **5** composition
2
timing
3 **4**
planning shutter speed
1 lens

▲ *A 1/30th sec exposure blurs the legs and arms of these participants in this 4 x 100m relay, conveying the high speed at which they are moving but still making it easy to identify individual athletes' faces.*

▶ *You can clearly see the tension in this shot putter's face. The photographer used a telephoto lens to avoid being dangerously near to the sportsman.*

6 Exposure

Subtle changes to the exposure setting can help you isolate figures from a cluttered stadium.

For example, if an athlete is competing in bright sunlight against a stand that's in shadow, try underexposing by half a stop.

This will mute the distracting sea of faces and multi-coloured clothing behind, so that they don't draw attention away from the action.

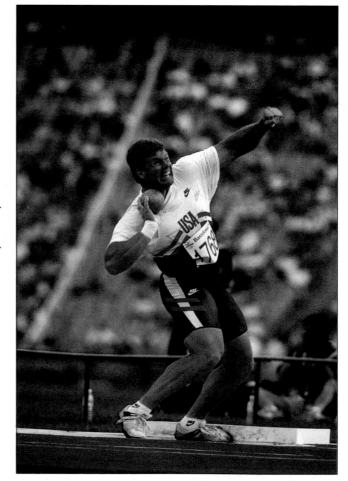

Horsing around

For animal shots, horses make great subjects. Their large size makes them an easy subject even with a compact camera. Why not experiment with close-ups of colourful bridles, too?

Whether you are a town or country dweller, you won't have to go far for four legged subjects. Local newspapers publicize shows, or find a riding school in your area. Horses are found in a variety of situations – for example, watch a foal close to its mother or a police horse and rider on duty.

Try taking semi-abstract shots involving horses – you could zoom in on a detail of the saddle and riding boots, for example.

► HEAD-ON VIEW
Taking a horse 'portrait' requires careful thought. If the animal is head-on, too wide an aperture means that not all of its head will be in focus. On the other hand, too small an aperture won't blur the background enough, so choose a medium aperture and focus on the eyes.

Here the stallion's windswept mane brings the study a little out of the ordinary. Framing him against a contrasting dark background helps make the mane stand out clearly.

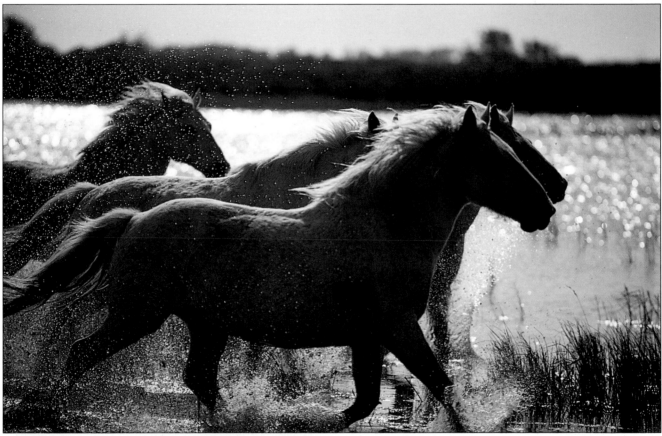

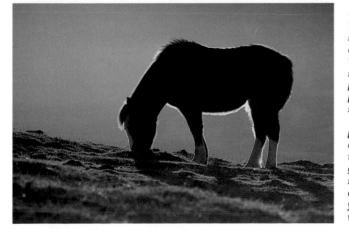

◄ RIMLIGHTING
What makes this shot extra special is the sunlight outlining every hair of the Welsh mountain pony. The soft morning light behind is a perfect background which picks out and isolates the subject.

With a telephoto lens, the photographer could keep his distance and avoid startling the pony yet ensure it was a good size in the frame. For shots like this, make a note of where horses graze near your home, then rise early when the light looks right.

▲ IN THE WILD
Wild horses in motion make a spectacular sight. If you're fortunate enough to see them, have a camera at the ready. You'll have to be quick! With a fast moving subject like this, leave plenty of space around the frame so you can crop later.

Careful metering of these Camargue horses results in semi-silhouettes. Light outlines their backs and flowing manes. A fast shutter speed lets you make out the individual drops of water suspended in the air.

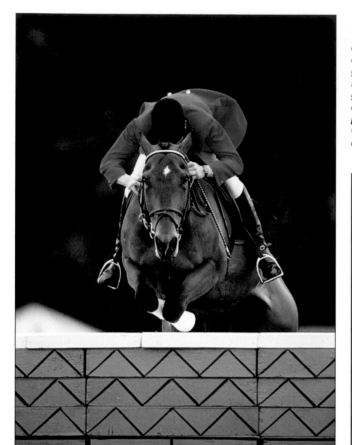

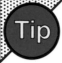 **IN MID AIR**
Visit a horse show for the chance of capturing the classic jumping pose. A seat gives you more chance of shooting without people getting in the way. At this outdoor show, the photographer chose a viewpoint where he was opposite trees, for an uncluttered background.

A long lens lets you fill the frame. Prefocus on the jump and press the shutter release an instant before the rider is sharp, because there's a delay before the shutter opens. Here your attention is concentrated on the horse because the rider's face is hidden.

Tip

Be prepared

❑ For successful horse show shots, a long lens helps isolate the competitors from the heads of the crowd. Indoors you'll need a fast film because of the low lighting conditions.
❑ A zoom lens is handy whatever the setting. It allows you to take close-ups and wider views without having to move too near the animals.

❑ If you're outside at a three day event, take along a shooting stick or folding chair so you can sit in comfort.
❑ To photograph an individual horse, ask someone to hold the reins. If you don't want a human in the shot, ask them to release the reins and be ready to press the shutter at that instant. You'll find race horses are especially lively!

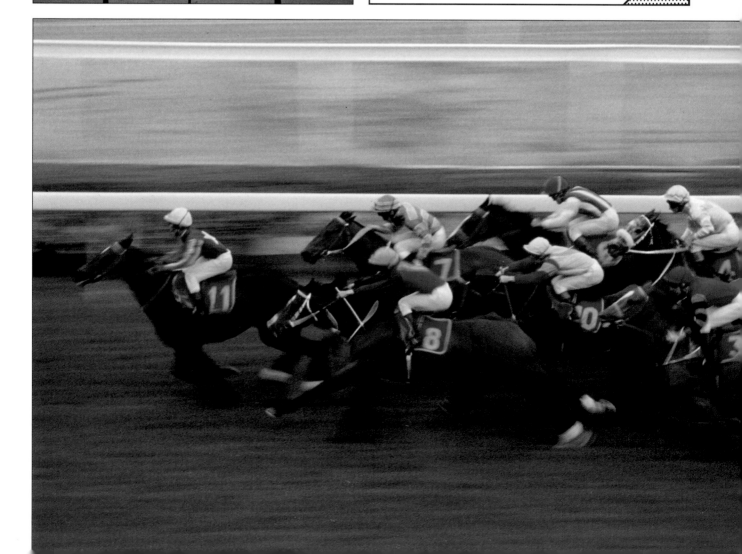

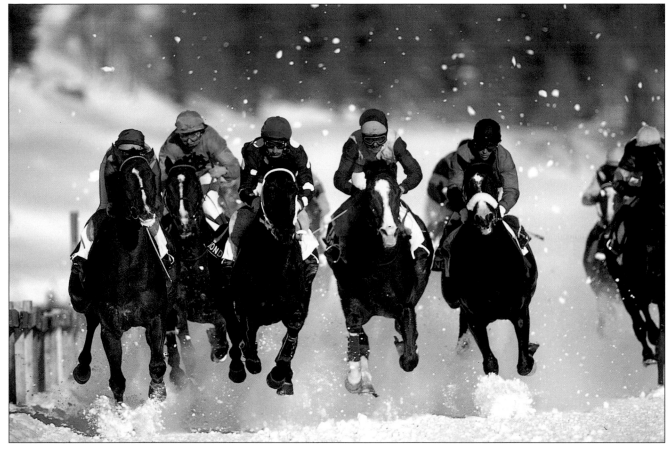

▲ NECK AND NECK

A string of race horses in full gallop looks striking with snow thrown up high above the jockeys. For this view the photographer stood at a sharp bend in the track. To capture the horses grouped tightly together, shoot at the start of the race – by the end, the field will have spread out.

The contrast between the dark horses and pure white snow can cause metering problems. Use print film rather than slide for the best results.

◀ UNUSUAL ACTION

Here the photographer made use of a track-side vehicle keeping up with the racehorses to portray action in a radically different way. The jockeys and horses' bodies are frozen because they are static relative to the camera, but other parts of the scene, including the hooves, are moving rapidly and therefore blurred at the slow speed chosen.

▶ SPLASH

Water hazards at three day events always have photographic potential. For safety don't get too close, and protect your camera from water – and mud – if it's not weather-proof.

Be prepared to be jostled if there are lots of photographers at the same spot. A zoom lens lets you frame the picture precisely without having to lose your position.

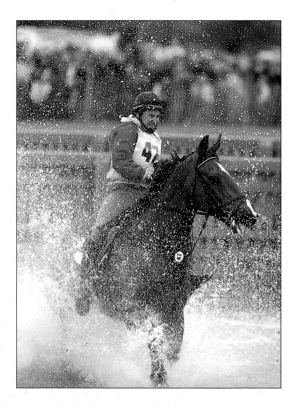

▶ AT WORK

Ploughing matches have a great advantage for photographers – the ploughman gains points for a straight furrow. This means it's easy to predict exactly where your subject will be, so you can focus and frame the picture well in advance. Here the soft sunlight bathes the horses in a golden glow.

▼ OUT HUNTING

For the best pictures, it helps if you have personal contacts with hunt members – most hunts are wary of attention from opponents of the sport. With the promise of a few prints, however, you may be lucky. Here, weak autumnal sunlight catches the masters and hounds, and the trees frame the group well.

▲ MUSICAL DRIVE

Heavy horses may appear at agricultural shows. The drivers often have potential as photographic subjects.

▶ AT HOME

Capture a resting horse during a quiet moment in the stables. Make sure you meter for the horse itself, otherwise it may be lost in the shadows. Check for litter before you shoot – it's easy to miss a discarded food sack intruding into the corner of the frame.

If your subject seems camera shy, ask the owner if you can offer it some of its favourite food. Very soon you should see a head appearing!

Martial arts

For exciting picture opportunities, try exploring the different branches of the martial arts – whether posed or unposed.

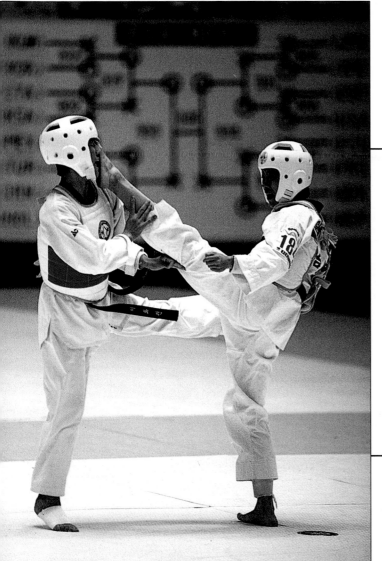

1 Lens

Many sports demand long lenses, but the martial arts is one area where you can use a standard or wide angle lens successfully.

A lens with a focal length of at least 28mm is recommended if you are close by and want to make sure that your subject's leg or arm does not travel out of the frame.

In sports like Karate and Jiu-Jitsu, the action is surprisingly fast. Even if you're using a wide angle lens, leave a space round your subject in the frame so that you can fully record any high kicks or jumps as they happen.

A longer lens is the order of the day if you're shooting at a competition and you can't get really close to the action.

If you want to freeze action in mid-air, try to take lenses with a wide maximum aperture, like f2.8. This lets you use as fast a shutter speed as possible.

2 Background

One problem with this activity is that the people taking part usually wear the traditional white clothing. This doesn't make for colourful pictures!

Get round the problem by choosing to shoot in front of a coloured background. Do make sure it's not cluttered though – a wide aperture will blur confusing details.

If you know someone who's a keen participant, so much the better. In exchange for a few photos, you could ask them to pose for you outside, or in the studio. For example, the green foliage of a park will liven up the shot. Or you could use background paper in a bright colour like red.

◀ *A wide aperture ensures that the competition ladder in the background is blurred enough not to compete with the subject. The photographer has caught the action just at the moment of impact.*

3 Location

Wherever you live, there's bound to be a martial arts club that meets regularly. Try contacting schools, gyms, youth clubs or community centres. Training sessions are a good opportunity for you to learn the most photogenic moves. That way, you'll be more confident when it comes to shooting at a tournament.

Don't overlook those martial arts which are not competition orientated. Aikido and Kung-Fu, for example, can provide plenty of inspiration for you. For classes, see a local paper.

▼ *Martial arts images don't have to be action packed! Here the photographer spotted these items necessary for Kendo lying on the floor, and slightly rearranged them for a pleasing composition.*

4 Lighting

Unless you're lucky enough to be within a couple of metres of the participants, flash is useless. In any case, you'll often find that it is banned during competitions.

So, if you're shooting indoors at a competition or exhibition match, take along some fast film of ISO 1000 (pushing slower film leads to grainier shots). If you're in the studio, using flash or tungsten is often a better option.

▶ *This shot was specially set up in the studio. One light was trained on the white background paper to produce an interesting effect.*

Exposure

As with other white subjects, it's easy to underexpose. The fast action makes bracketing impossible – even if your camera has autobracketing, your best composition may not be the best exposure.

So, use print film, because slight exposure errors aren't a disaster. (It also lets you crop your shots afterwards.) In the studio, you can control everything and ask your subject to repeat a move if you want to try a different exposure.

▼ *Martial arts can be amazingly graceful. Pushing fast film allowed shooting without flash, which would have spoiled the serene atmosphere.*

6 Viewpoint

Being in the correct position is vital for successful pictures. Where you are shooting a flying side kick, for example, you should aim to capture the leg extending across the picture frame.

With two participants, try not to shoot where one is blocking the other from view. You'll end up with a confusing subject and, often, not enough depth of field to record both people sharply.

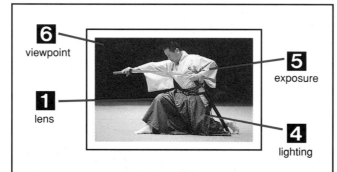

viewpoint — **6**
lens — **1**
5 — exposure
4 — lighting

CHECK IT! ✔

Camera: SLR – one equipped with a motordrive is useful.
Lens: 28, 24mm or even wider; if you can't get close, up to 200mm. Choose fixed focal length lenses in preference to zooms, for their wider maximum aperture.
Film: indoors at a tournament, ISO 1000; in the studio or outside, ISO 100. Print film is recommended as it's tricky to bracket.
Filter: not usually necessary.
Camera support: not recommended.
Location: gym, school, college, community centre, health club; for competitions, hall; for set up shots, studio.
Safety note: if you are very close to the action, watch out that the competitors don't knock into you.

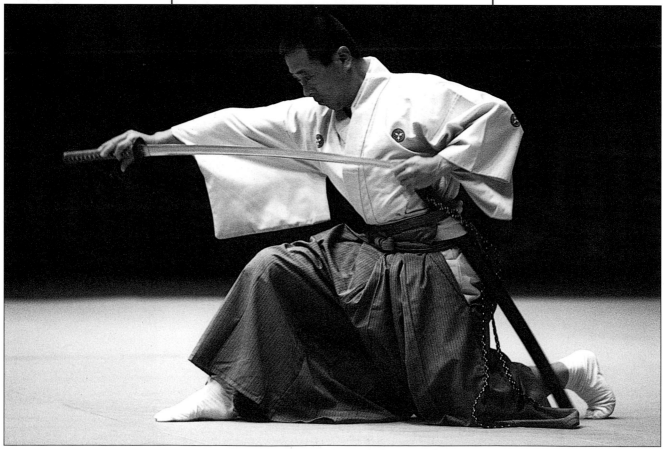

Photographing skateboarders

Skateboarding is a high-speed, action-packed sport that's full of thrills and spills. Tim Leighton-Boyce shows Bill Bradshaw how to tackle this high flying pastime.

My involvement with skateboarding was a painful and shortlived affair. As a teenager, I threw caution to the wind, bought a skateboard and proceeded to fall off and break my arm on the first run. This marked the end of my skateboarding career.

In spite of my bruised ego and broken bones, I've remained fascinated by the sport ever since, and have often thought about photographing skateboarders and their death-defying antics. So when Tim Leighton-Boyce invited me to accompany him on a shoot to see how it's done, I leapt at the chance.

Tim arranged for us to meet up with two young skaters, John and Simon, at a skate park in East London. The venue contains a variety of purpose-built ramps and moguls (concrete bumps) for the skaters to perform on, which gave us plenty of scope for action-packed photographs.

Manic manoeuvres

When we arrived, John was performing daredevil stunts on the 'vert ramp' – a U-shaped ramp with six-metre-high vertical sides. We positioned ourselves on the platform at the top of the ramp and I watched in amazement as John whizzed from side to side at breakneck speed. Having studied a few of his manoeuvres, I felt ready to start.

I plumped for a 135mm lens fitted to a Canon AE1 camera body, which I loaded with Fuji RDP ISO 100 slide film. Because John was moving so very quickly, I set a shutter speed of 1/250th sec in the hope of recording a sharp image. Unfortunately, the sky had begun to cloud over, so I had to open up the lens to an aperture of f2.8. This limited the depth of field and meant that my focusing had to be spot on.

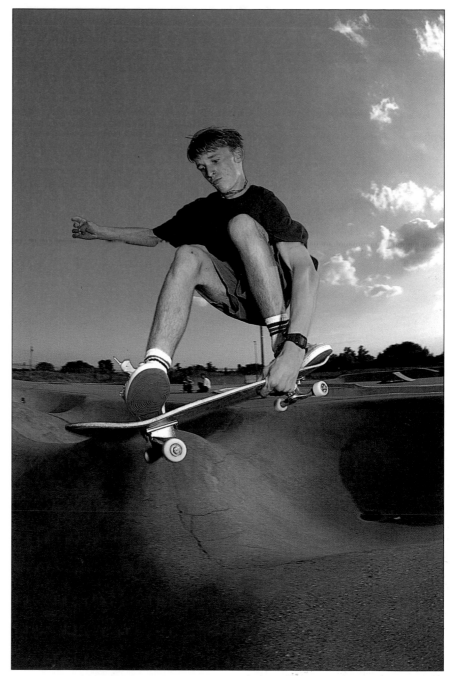

▲ *This striking picture of Simon leaping over a concrete bump is typical of Tim's skateboard shots. It is brightly lit, makes good use of the close focusing and distorting effects of a full frame fisheye lens, and catches the moment perfectly. If there isn't a skate park near where you live, visit playgrounds and large car parks – both are favourite haunts of skateboarders.*

◄ *Tim Leighton-Boyce is a professional photographer who specialises in photographing skateboarders for international skateboard magazines.*

CAPTURING THE MOMENT

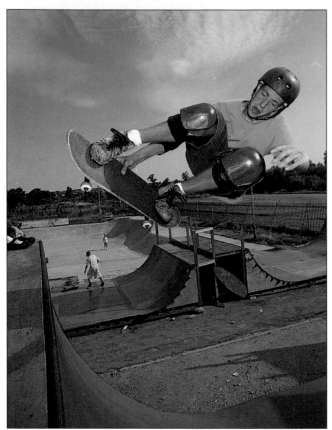

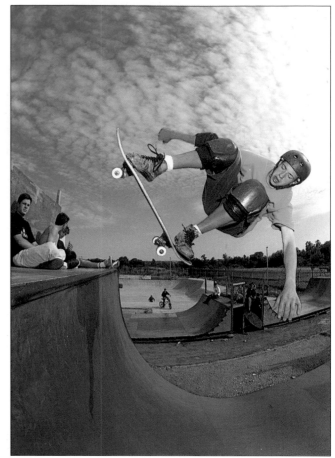

1 A SIDE-ON VIEW
Tim prefers to use wide angles, so he opted for a 24mm lens. The wide framing and side-on view let him show John in mid-flight. He also used flash to 'lift' John from the background. To calculate the exposure, he first worked out the correct aperture for the flash (f5.6) and set this on the lens. Then he metered from the sky and set the appropriate shutter speed (1/125th sec) on the camera. Mixing daylight and flash in this way gives bright, almost overlit, pictures that suit the brash subject matter.

2 A CHANGE OF LENS
Unhappy with the 24mm lens, Tim decided to switch to a 15mm full frame fisheye. This is his standard tool for skateboarding pictures. The fisheye gives wide depth of field – even when you use wide apertures and focus on subjects close to the camera. This makes accurate focusing less important, though Tim still aims for the sharpest possible results by prefocusing on a point at the top of the ramp. The lens' wide angle of view takes in a vast expanse of sky, which creates an impressive backdrop.

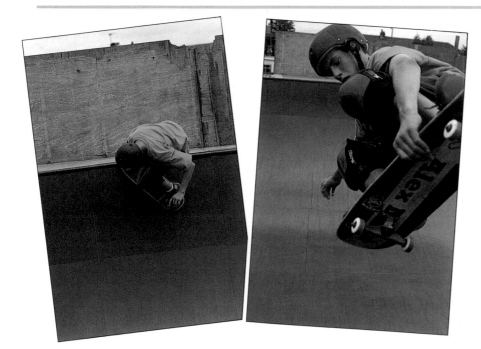

Too fast to capture
As soon as I started shooting I realized that capturing a good shot was not going to be as easy as I had thought. I tried firing the shutter as John reached the top of the opposite ramp, but all I could see was the top of his helmet. In an attempt to improve the shot, I changed to a 50mm lens and tried to snap him as

◀ *Bill's first shot looks flat and suffers from poor composition – John is small in the frame and you can't see his face. Also, the picture fails to capture a sense of fast-moving action. Switching to the 50mm lens and shooting John at closer range gave a more interesting picture. But the lens' fairly narrow field of view meant Bill only saw John in the viewfinder at the last moment, making accurate composition impossible.*

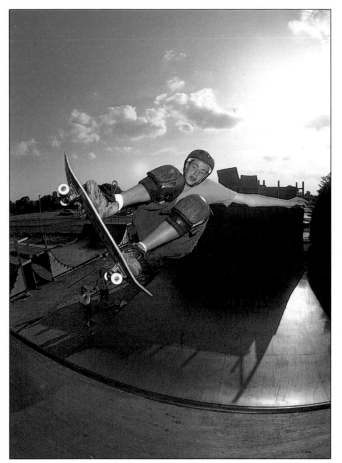

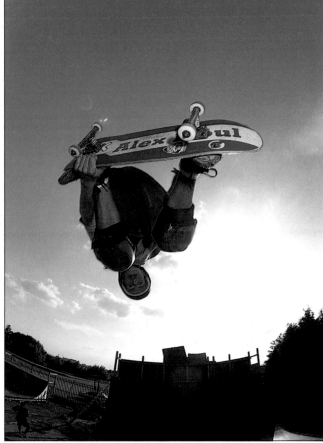

3 A DIFFERENT VIEWPOINT

For his next shot, Tim changed his viewpoint so he was shooting straight down the ramp. This let him fill the foreground with part of the platform. The distorting effect of the fisheye makes the lip of the ramp appear curved, which makes for a more dramatic composition. He also set a faster shutter speed of 1/250th sec, which darkened the sky and the background. This places more emphasis on John. By including the spectators at the bottom of the ramp, Tim was able to exaggerate the impression of height.

4 SHOOTING AT ARM'S LENGTH

On several runs, John twisted through 180° at the top of his jump – so he was hanging upside down in mid air for a brief moment. Tim wanted to capture this sensational manoeuvre and decided to photograph John from underneath for maximum effect. As soon as he leapt into the air, Tim held his camera out over the ramp, pointing up at John, and fired the shutter. He was able to shoot just one frame before he snatched the camera out of John's way. Even so he managed to time the shot to perfection.

he reached the top of the ramp in front of me. However, this made it very difficult to focus, because of the speed he was moving at and his closeness to the camera. Frustrated with my lack of success, I handed over to Tim.

The first thing he did was to sit down and wait for the blue sky to reappear. 'Skateboard shots look very dull against a grey sky', he told me. 'It's worth the wait to make sure you shoot against a rich blue background.'

Tim's patience paid off and within half an hour the sun was out and the sky was blue. He decided to fit a 24mm lens to his Canon T90, so he could take in a wider view of the scene. Having loaded a roll of Fuji Velvia ISO 50 film, he attached a powerful hammerhead flashgun to the camera. 'I always use flash, because it brings up colour and detail, and helps to freeze the skaters' movements', he explained.

Through a fisheye

Having rattled through a roll of film, Tim switched to a 15mm full frame fisheye – the most popular lens for skateboard photography. This lens has a 180° field of view and gives a dramatic, distorted image. It also gives a very wide depth of field, even at wide apertures, and lets you photograph from close to your subjects.

Tim tried several compositions, shooting from a variety of angles to come up with a series of spectacular skateboarding photographs.

The set up 1

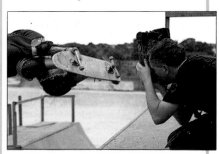

Tim and Bill photographed John from a platform at the top of the 'vert ramp'. Tim used a Canon T90 camera, 15mm full frame fisheye lens, Metz 60 CT1 flashgun and Fuji Velvia ISO 50 slide film. The fisheye enabled him to shoot a few centimetres away from John.

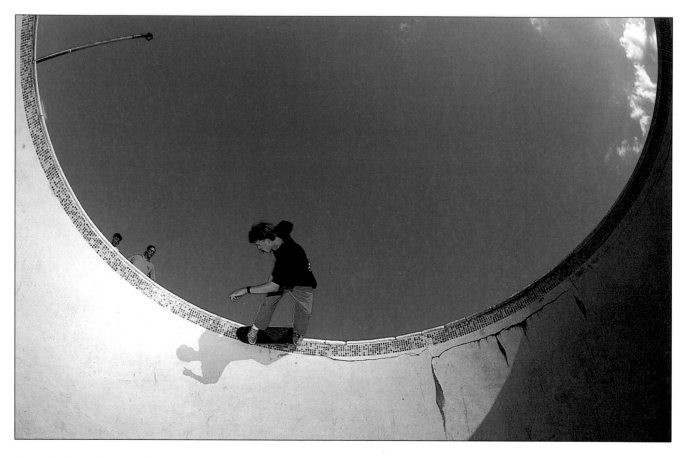

For the last shot in the series, he held the camera out over the ramp, underneath John, for a breathtaking upside down view. He was careful to snatch it away as soon as he'd taken the shot, however, so that it didn't get in John's way and cause a serious accident.

For an alternative approach, Tim asked Simon to skate 'The Pool'. This is a sunken concrete structure, similar in appearance to a circular swimming pool – hence its name. He used the fisheye lens and flash combination to capture Simon, as he careered around the skateboarders' equivalent of the Wall of Death.

▲ *The unusual properties of a 15mm fisheye lens are perfectly illustrated in this picture. The lens' 180° field of view let Tim take in a large area of both 'The Pool' and the blue sky, for a graphic composition. The lens' distorting effect adds to the picture's graphic feel. Tim made sure Simon wasn't distorted by keeping him near the centre of the frame.*

The set up 2

'The Pool' is a sunken concrete bowl. Simon skates around the sides in the same way as motorcyclists ride the Wall of Death.

Tim crouched down at the bottom of The Pool and shot from below Simon. He used a Canon T90 camera, Metz 60 CT1 flashgun, 15mm full frame fisheye lens and Fuji Velvia ISO 50 slide film.

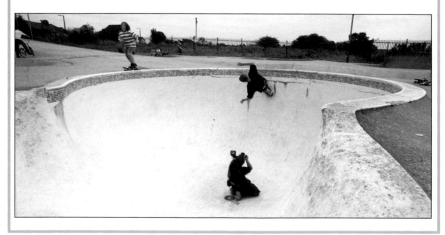

 SLR tip

❏ Fisheye lenses are expensive, and it's only worth buying one if you want to do lots of skateboard photography. A fisheye converter is cheaper, and gives a full frame fisheye effect with a standard lens, but quality is inferior to a prime fisheye. You just screw the converter onto the front of your prime lens.

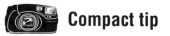 **Compact tip**

❏ If you use a zoom compact to take pictures of skateboarders, set the lens to its widest setting. Also, be sure to turn on the fill-in flash function for bright, punchy results.

On two wheels

With the right choice of lens and viewpoint, you can capture all the excitement, speed and sweat of a hugely popular sport: cycle racing.

There are several forms of cycle racing, offering a variety of photographic opportunities. One type is road time-trialling. Riders start at one minute intervals, giving you plenty of chances of getting an action portrait.

In another type of road-racing all the riders start together. Decide before the race whether to shoot the start, middle or finish.

You need a long lens for track races, which can be in or out of doors and involve shorter races around an oval track.

Cycling is a major summer sport in many countries, such as France and Italy. So be on the lookout for pictures when you holiday abroad.

◄ **FULL SPEED AHEAD**
Clamped to a monopod fixed to the bike frame, the camera records passing scenery. The setting is a bike path, with the yellow central dividing line and red and yellow paper tied to bushes to add colour. The photographer used a neutral density (grey) filter so that he could set a slow shutter speed to blur the hedgerow. He triggered the shot with a cable release, via his tongue!

▼ **ON THE TRACK**
For frame-filling pictures of Indoor pursuit cycling, you'll need either a press pass or a fairly long lens. With a pass, you can reach the inside of the track, and shoot close-up like this shot, using flash to add sparkle. From public areas, you can use a telephoto to get similar pictures, but your subject will be out of range for flash, so take a monopod support and use fast film.

▶ MOUNTAIN EXCITEMENT

When the setting is as impressive as the cycling, bikes and riders can be quite small in the frame. This image, for example, has tremendous appeal as a landscape, on top of its cycling interest. The photographer took care to frame a competitor in brilliant red clothing to contrast with the predominantly blue hues of the rest of the image.

▼ PACK IT IN

For really dramatic images of a road race, make sure you catch the start. At this stage, all the competitors will be bunched together – whereas they spread out as the race progresses. Choosing a long telephoto, such as a 300mm, exaggerates the bunching and stacks the bikes and riders closer together still.

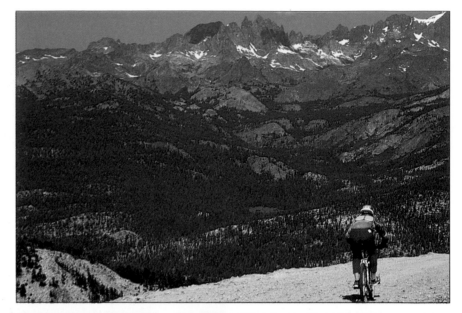

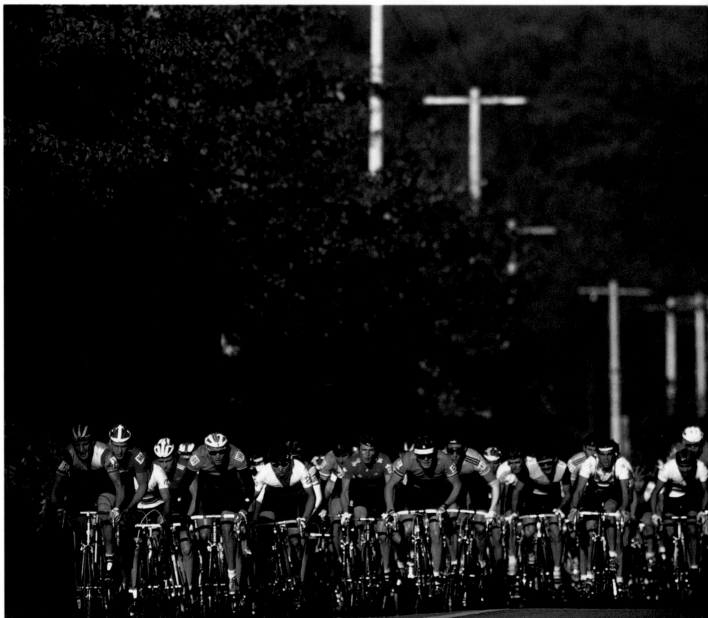

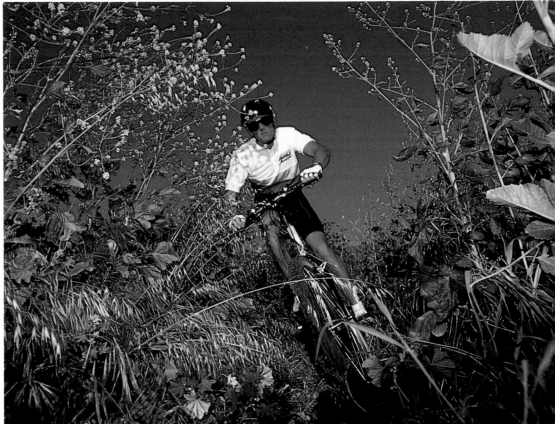

► CUTTING A SWATHE
To evoke the excitement and speed of mountain-biking, pick a low viewpoint. Your picture will show the cyclist in the context of the rugged terrain, and will frame the figure against the sky. Pictures like this one are easiest with the cooperation of the cyclist: you can pick a location with a suitable foreground, then get the cyclist to repeatedly pass the spot.

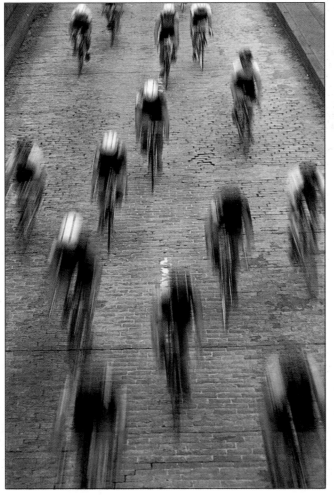

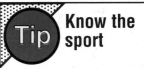 **Know the sport**

The more you know about cycle racing tactics the greater your chances of getting some shots to be proud of.

For example, in team races two cyclists from the same team will ride side by side, forcing a competitor to swing out on a bend in order to pass – so position yourself where you can catch this dramatic moment.

◄ BLOTS OF COLOUR
To suggest the speed of whizzing bikes, set a slow shutter speed. This unusual view blurs every figure, but works because the colourful jerseys lift the cyclists from the cobbled street. Shooting from a bridge with a wide-angle lens makes the figures converge steeply in the distance, and enhances the impression of motion.

► GOLDEN BOYS

The low intensity of early morning light may force you to use a wide aperture. This reduces depth of field, hiding background distractions, but it also makes focusing more vital. If you don't have an autofocus camera, preset the focus and shoot just before the figure is sharp. In the delay before the shutter opens, the competitor will pedal into the zone of sharp focus.

▼ MAKING A SPLASH

If you're shooting a fixed route cycle event, it pays to walk or cycle the course yourself beforehand (at the same time of day). Here, the photographer knew that early morning sun would create stunning reflections on the ford, and found a camera position that made semi-silhouettes possible. One stop more exposure than the meter recommended kept some detail in the figures.

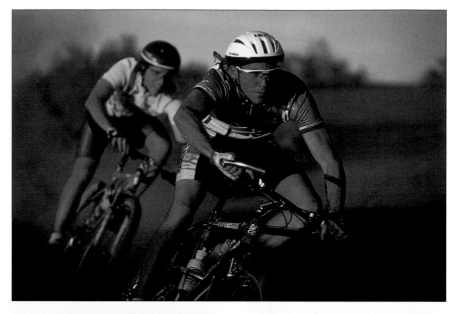

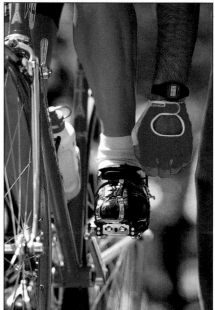

▲ WATCH IT!

Sometimes an oblique approach to the subject says much more than a conventional view. By closing in with a powerful telephoto lens at the start of a road race, the photographer caught a view that captures the tense moments of anticipation.

Shooting cyclocross

Capturing the fast pace and hard work of a cyclocross meeting demands a good viewpoint and quick reflexes. Sports photographer Frank Coppi shows Sarah Jackson how to tackle the job.

When I agreed to photograph a cycle race with Frank Coppi, climbing wet, slippery hills was not exactly what I had in mind. I'd assumed that we'd be photographing riders travelling round a track in a predictable pattern. Instead, I found myself in Southampton one overcast day, where a cyclocross race was to take place.

Cyclocross is not like other cycling events. At certain sections of the course, the riders have to dismount and carry their bikes through deep pools of water, up steep hills or any other terrain that is impossible to ride through at speed. In the process they get covered in mud as well as exhausted.

'The beauty of cyclocross', Frank explained to me, 'is that you can capture a whole variety of shots. But you must do your homework first, by walking round the course to find viewpoints with the most potential for pictures. Many races – including this one – are run over several laps, so you have more than one chance of photographing each competitor.'

Walking the course

The course began – and ended – on an athletics track. Otherwise it consisted of a taped off path which led past trees, up and down steep slopes and through puddles of varying sizes. Frank was particularly taken with a section which had a steep upward gradient. 'The competitors will have to get off here and carry their bikes', he said. 'If we stand where the track bends round,

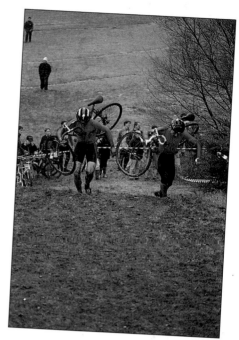

▲ Sarah was right in thinking that these two colourfully dressed competitors would make a good subject. However, they are far too small in the frame. She should have waited until they had run a few metres nearer to the camera. This would also have had the effect of separating them from the confusing background of the spectators.

▼ One section of the track passed through woodland. Light levels were low but Frank had come prepared with a flashgun. He selected the flash setting, then waited until a competitor was at the right distance before shooting. Fill-in flash picks out the figure from the gloom and freezes his movement.

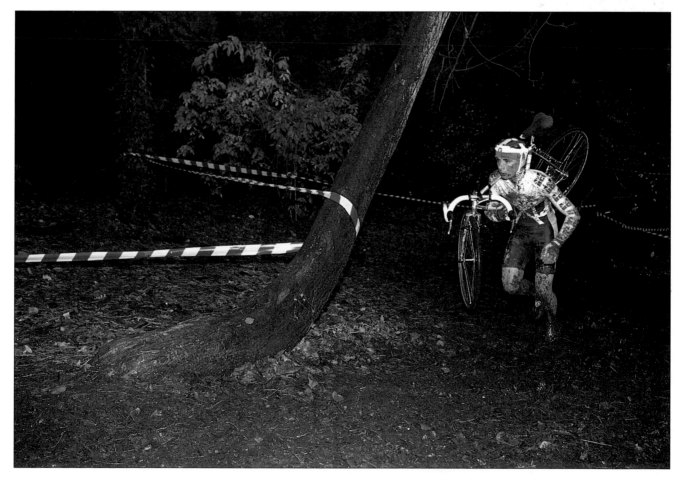

we'll have a good view of them as they come over the ridge.'

We found a spot just behind the tape where we could photograph the competitors running up the hill. By turning round we could also photograph them as they ran past, between us and the trees.

As the light level was quite low, Frank decided to use Fujichrome ISO 100 slide film, pushed one stop to ISO 200. He had brought along fast lenses, which all let him set an aperture of f2.8. 'That way I can set shutter speeds of 1/250th second, to freeze running figures', he said.

Too distant

As the competitors set off below us, Frank and I got ready. I had brought along my Pentax ME Super and a 28-80mm zoom. When I spotted two figures, almost identically dressed in pink and black, running up the hill with their bikes hoisted on their backs, I quickly took a photograph. Too quickly, as it turned out – they looked very small in the final shot. I should have waited until they were a few metres closer to me.

Meanwhile, Frank had fitted an 80-200mm zoom to his Nikon F4, which has a motordrive built-in. As the first figures came over the ridge, he photographed them bunched together. Then he crouched down so that he could exclude spectators from the frame.

By turning to his right, Frank could photograph competitors as they made their way up the slope, already covered in mud. I noticed that he shot off much more film than I had, to increase his chances of capturing the best pictures.

Frank pre-focused on a midway point on the track as the racers came up the hill, shooting the moment they were level with him. He managed to capture one rider

who had parted company with his bike a split second before he vanished out of the frame.

Wide angle

You don't normally associate sports photography with a wide angle lens, but Frank decided to fit a 24mm so that he could show the riders in context. He picked the moment to shoot when one rider nearly lost his footing. Frank says, 'When there are several riders, all carrying their bikes, the shot can end up looking a little confused. Wait until the competitors have separated out before you shoot. This only takes a lap or two.'

For his final shot in that position, Frank wanted a close-up of one

CAPTURING THE ACTION

1 ► COMING INTO VIEW
Frank positioned himself so that he had a good view of the competitors coming over the ridge on foot. He used an 80-200mm zoom, set to around 200mm so that they were a good size in the frame. But the spectator on the left hand side is distracting.

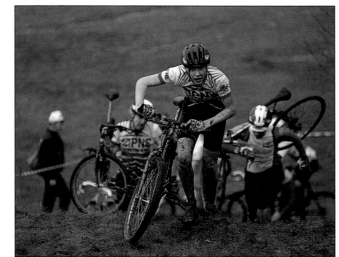

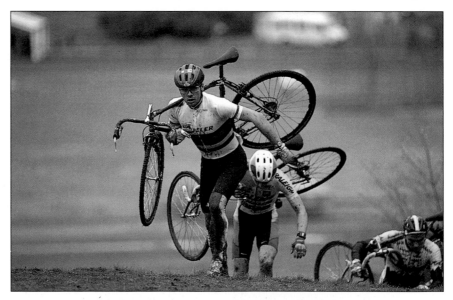

2 ▲ A LOWER VIEWPOINT
Frank crouched down so that he could separate three of the figures from the rest of the pack. This let him hide any spectators from view. The 200mm focal length means that the background is blurred enough not to be confusing.

The set up

Sarah and Frank were shooting a cyclocross event in Southampton. The course started off on an athletics track, then made its way up a hill and through trees, before returning to the athletics track. The competitors had to cover several laps.

Sarah used a Pentax ME Super SLR with a 28-80mm lens and Fujichrome ISO 100 film. Frank used a Nikon F4 together with 24mm, 35-70mm and 80-200mm lenses. He shot on Fujichrome 100, pushed one stop because of the bad light. In the wood, he used a Nikon SB24 flashgun.

racer. The longest end of his 35-70mm zoom let him capture one muddy competitor, his bright pink bike hoisted on to his shoulder.

I thought that was his last shot, but Frank had other ideas. He followed the course as it went into woodland, then found a spot behind the tape where the course bent round. It was very dark under the trees but Frank fished a powerful flashgun out of his gadget bag. He attached it to his camera's hotshoe and calculated the settings, then settled down to wait.

Soon a lone running figure appeared. As he turned the corner, Frank took a picture. In the resulting shot, flash picks out the rider from his surroundings, but you can still make out the background clearly.

Frank points out, 'Fill-in flash is often used when photographing cyclists, and no wonder. In dim light you can use it together with a fast shutter speed to freeze the motion of a fast moving figure. I usually underexpose the flash by one stop to avoid the figures looking burnt out.'

3 ▶ RUNNING PAST
By turning to the right Frank could record the competitors as they passed close to him. Using a 35-70mm lens set to around 50mm, the framing was tight enough for them to be a decent size in the frame but not too tight that the subject was partly cropped out of the picture.

4 ▼ BIKELESS RIDER
While he was shooting, Frank spotted a rider who had become separated from his bike and was sliding in the wrong direction. He had just enough time to release the shutter before the man slithered out of the frame.

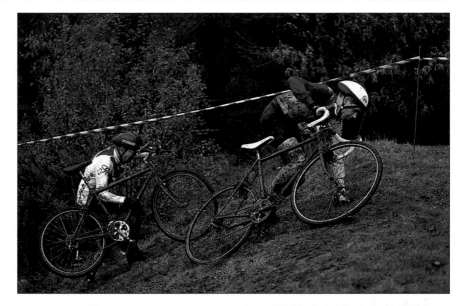

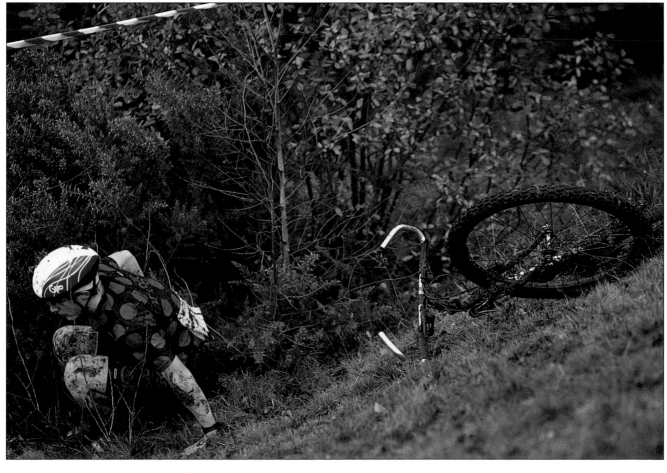

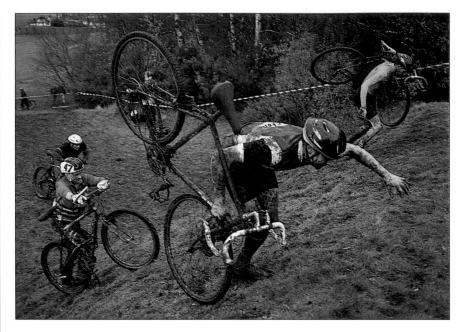

Compact tips

❏ If your compact is equipped with fill-in flash – or flash that you can switch on manually – you can make use of this feature to create eyecatching shots of the competitors as they rush past you. But do bear in mind that your subject must be within flash range, otherwise the flash will have no effect. Read your camera manual for the precise distance that the flash can reach. This varies according to the lens' focal length and speed of the film you are using, as well as the camera model you have chosen.

❏ Slow synch fill-in flash, which can be found on advanced compacts, is excellent for taking creative shots of cyclists. The flash illuminates the competitor, while the shutter stays open long enough to record the rest of the scene by available light. The overall effect is to record anything that moves as a blur as well as a sharp image, giving a suggestion of movement but still showing details clearly.

5 ▲ WIDER VIEW
Swapping the zoom for a 24mm wide angle lens meant that Frank could show more of the course. He crouched down, waited until four of the competitors were quickly making their way up the hill, then released the shutter. What makes this shot stand out is the stumbling figure in the foreground.

6 ▼ CLOSE-UP
One shot not yet taken was a close-up of a rider with his bike hoisted aloft. Frank swapped back to the 35-70mm zoom lens, chose a focal length of 70mm and waited for his opportunity. Sure enough, along came this muddy competitor. Luckily his bike frame was bright pink, injecting some colour into the shot.

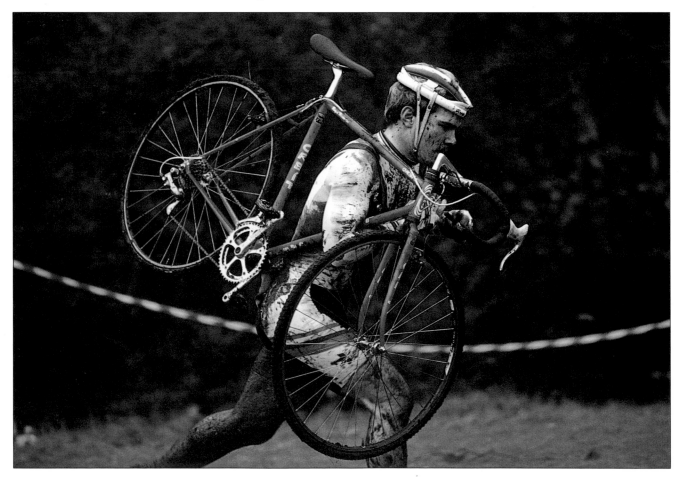

Marathons

Whether it's the agony on a competitor's face or candids of colourfully dressed spectators, marathons provide the photographer with a rich source of material.

The great advantage of marathons is that there's plenty of time to capture a wide variety of subjects. To make the most of the race, however, planning is essential. A map of the route (you should be able to get one in advance from the organizers) is very handy in helping you to select the best viewpoints, so that you know where to aim for on the day itself.

At the start of the race, when all the competitors are bunched up together, a high viewpoint, say from a bridge or tall building, is often most effective. An image which captures the huge numbers of people involved in these events looks very dramatic.

If you are at a roadside position, be sure to get there early. Otherwise you may find that your viewfinder is filled only with the backs of other spectators' heads!

During these long endurance races, sheer physical effort and frequently agony registers clearly on participants' faces. With a telephoto lens you can fill the frame with contorted expressions for very telling shots.

As time is not a limiting factor in this sport, it is worth experimenting with slightly unconventional views of the event to complement your more orthodox pictures. Get in really close and low with a wide angle lens for a shot which makes your viewer feel involved in the action. Or use a slow shutter speed to ensure a strong sense of movement and capture the runners as a colourful blur as they rush by.

▼ **LONELY RUNNER**
Isolating runners is easiest at the end of the race when the field is spread out. Here a high viewpoint coupled with a telephoto lens allowed the photographer to exclude stands and spectators.

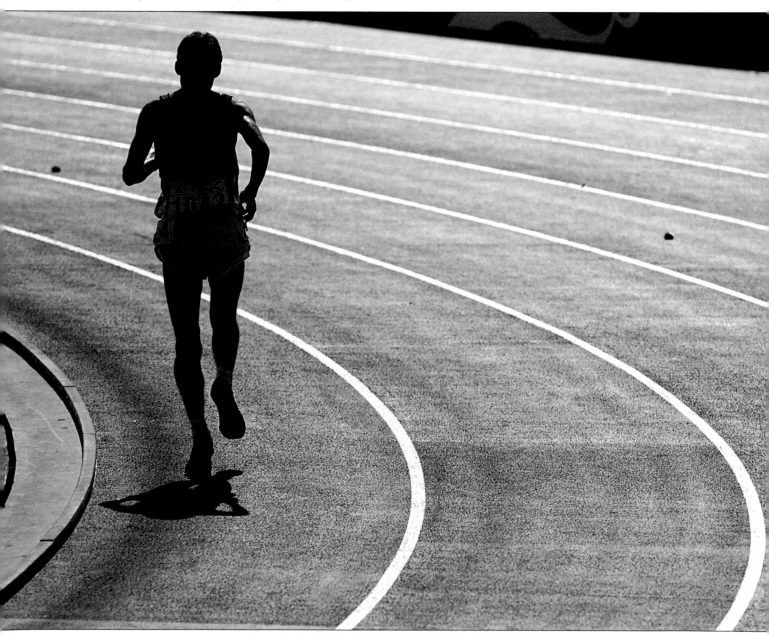

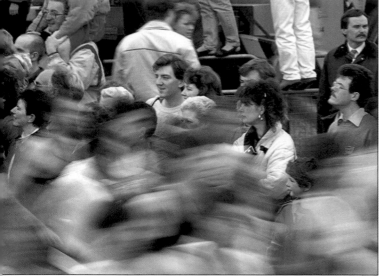

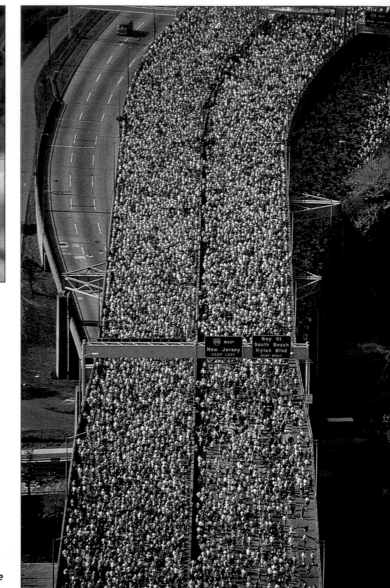

▲ BLUR OF SPEED
For more evocative shots of events, experiment with different shutter speeds. Here, an exposure of 1/8th sec was slow enough to catch the runners as a flash of colour, but fast enough to freeze the spectators behind them.

▶ WAY DOWN BELOW
The mass of competitors all clustered together at the beginning of a race is best photographed from a high camera position. A skyscraper overlooking the route provided an excellent viewpoint for the start of the New York Marathon.

▼ THE FRENCH ARE COMING!
Famous city landmarks such as the Arc de Triomphe make an attractive background as well as providing a focal point in marathon pictures. A zoom lens allows you to frame the image precisely.

▶ BLAST FROM THE PAST
Runners in fancy dress brighten up and add a touch of humour to races, but making them stand out from the crowd and other runners requires a little planning. Choose a viewpoint where you can frame runners against a neutral background, or set a wide aperture to blur the surroundings, as the photographer did here.

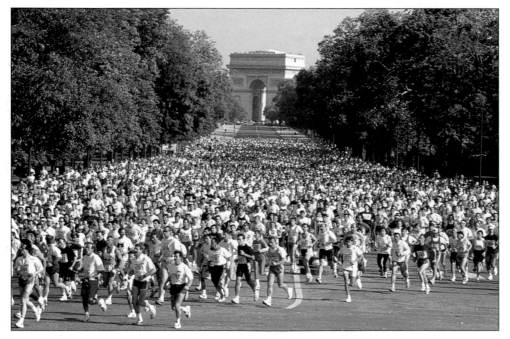

▲ MADE IT!
At the finish of races, look for the sense of relief which registers on the faces of competitors. The Mylar blankets distributed to runners also add a brilliant, sparkling touch to any scene. In this shot, the photographer took a reading from the subject's face to avoid underexposure.

▶ A LOAD OF RUBBISH
For less conventional pictures of marathons look for telling details such as these discarded empty water bottles. The use of a wide angle lens has produced a dynamic effect.

▼ TRIUMPHANT PAIR
Try to photograph winners away from the clutter of the finish line. Here, a colourful poster behind the winners' rostrum provided an excellent backdrop for the happy subjects.

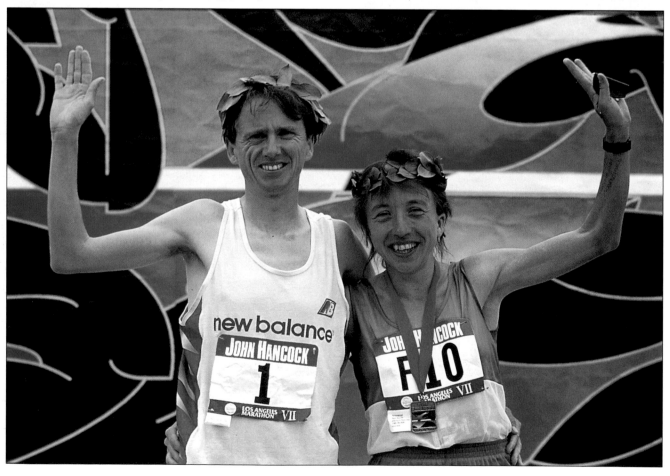

10 tips for better
sport and action photography

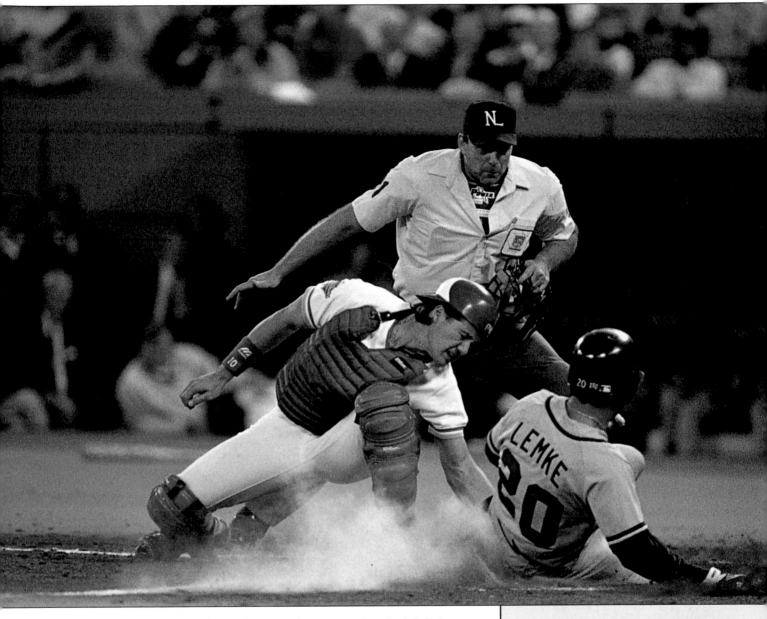

Finally, before we look at dance photography (which is surprisingly akin to sports and action), let's just recap the ways to get really good pictures in whatever your chosen sport may be. Equipment is important, yes; but technique, experience and quick reactions can be even more crucial.

1 Know the event

Choose an event you are familiar with. Most sports occur at a fast pace so you must have quick reflexes to capture the action at the right instant. With a thorough knowledge of the event – especially if there are complicated rules – you'll be in a much better position to anticipate the action, however fast moving it is.

With team sports, concentrate on the key players around whom the game revolves. You may need to do some homework before the event. When you have identified them, follow the principal subject in the viewfinder until a suitable moment appears, such as a quarterback making a winning pass or a hockey player shooting at goal, for example.

long focal length blurs spectators in background

low viewpoint adds to drama of picture

▲ **BASEBALL ACTION**
A knowledge of a sport's rules allows you to anticipate the action. Here, the photographer caught the dramatic moment when the hitter slides into home plate.

2 Select a good viewpoint

Successful action photography depends on careful choice of viewpoint. At major sporting events the best camera positions, like the touch-line at a football match or infield at a top athletics meeting, are usually reserved for professional photographers.

However, all is not lost for the keen amateur. You can take advantage of local venues or amateur events where there are far fewer restrictions.

Although the 'star' names may be absent, there are still plenty of opportunities for exciting shots. A letter to the club secretary and the offer of complimentary photos often secures a pass.

At track sports such as horse racing, athletics and motor racing, try positioning yourself on a bend where the field turns and often appears to bunch together dramatically as it races past.

Jumping events often look spectacular from a low viewpoint with the subject framed against the sky. For a really striking shot, crouch down low to capture the sand being thrown up as a long jumper makes his landing.

If you are limited to shooting from high up in a stand, you can still obtain very acceptable results with a long telephoto lens (400mm and above). Use a monopod to steady the camera and lens without sacrificing mobility.

Try to obtain permission to attend some of the training sessions. Unhindered by spectators, you'll be able to walk around much more freely and move in close to your subject.

► **FLYING HIGH**
Using a telephoto lens together with a low viewpoint dramatically captured long jumper Mike Powell in full flight as he attempted to set a new world record.

3 Isolate the subject

Concentrate attention on a single subject by moving in close with a telephoto lens or selecting a viewpoint which excludes spectators or other distracting details. Filling the frame with a wrestler flexing his muscles or the look of exhaustion on a marathon runner's face con- veys a sense of drama that you won't find elsewhere.

When photographing a moving subject, compose the shot to suggest the direction of the movement. Positioning a sprinter leaving his blocks in the centre of the frame, for example, gives a static feeling of balance inappropriate for the subject. But place the same figure off-centre towards the left hand side of the viewfinder (if he's running to your right) and you can graphically convey the impression that he is moving forwards into the space left at the other side.

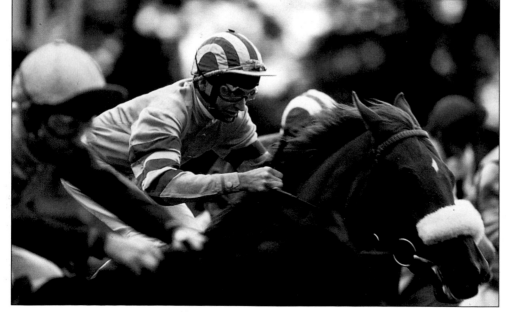

◄ **NECK AND NECK**
The narrow depth of field of a telephoto lens combined with precise focusing isolates jockey Steve Cauthen in a busy field of runners.

4 Watch the background

Don't forget the background when you are ready to shoot. Depending on your viewpoint, a subject can easily become lost against a mass of spectators. Avoid this by setting the largest aperture available. This throws the background out of focus and makes your subject stand out clearly.

Watch out, too, for people not directly involved in the action. A picture of a golfer teeing off is easily ruined if his partner, standing behind him, is only half in the frame.

Alternatively, include the background to show the context of the action. A photograph taken from a high viewpoint of a ski jumper framed against the valley below, or of a cyclist against a spectacular mountain backdrop, for instance, makes an eyecatching picture.

If you can move close enough, use a wide angle lens to include the environment in the shot. The extensive depth of field of these lenses also helps keep detail in the background as well as the foreground pin sharp.

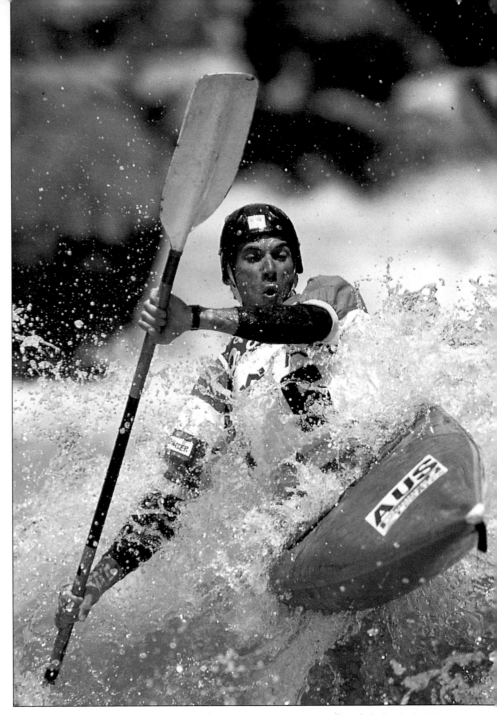

▶ **WHITE WATER**
A wide aperture throws the background out of focus, concentrating attention on the canoeist. A fast shutter speed freezes the action.

5 Wait for the decisive moment

Capture the excitement of a sporting occasion by anticipating and shooting the climax of the event. The moment a basketball player puts the ball through the hoop and the instant a winning sprinter crosses the finish line with head dipped and arms aloft provide classic action images.

Within a split second the opportunity is sure to have vanished, so before the event make sure you know how to use your camera without hesitation. Pre-focus on a point where you think the action will reach a climax and have all the settings ready so that you can concentrate on the crucial moment.

A good time to shoot the high point is just before the action changes direction. For example, this could be a tennis player, racket swung back, on the point of hitting the ball or a gymnast preparing to make the final backflip in their floor routine. As the action slows momentarily, this means that you can also set slower shutter speeds than usual and perhaps manage with a slower film or lens.

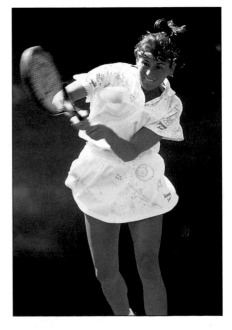

▶ **RETURNING SERVICE**
The moment a tennis player hits a return can usually be anticipated. Even with a fast shutter speed of 1/1000th sec the movement of ball and racket is captured as a blur.

6 Freeze the action

Set a fast shutter speed to stop action and capture movement which is too fast for the eye to see clearly. You'll need the highest shutter speed available to record, say, a razor sharp image of a high diver entering the pool or the dust thrown up by a rally car shooting past. Most SLR cameras are capable of using shutter speeds of at least 1/1000th sec, allowing you to freeze all but the fastest action.

Always take into account the distance between the camera and the subject. The larger your subject appears in the viewfinder, the faster its apparent speed and the

faster the shutter speed required. Movement towards the camera also appears slower than movement across the frame.

Fast shutter speeds are governed by the available light so choose a

lens with the widest maximum aperture that you can afford. Combined with a fast film (ISO 400 and above) you'll be able to work even when the available lighting conditions are poor.

▼ PARIS-DAKAR RALLY
Fast shutter speeds are essential to freeze the action of fast moving sports such as car rallies. In dusty conditions, as here, make sure your camera is well protected.

fast shutter speed freezes subject and the dust it kicks up

telephoto lens lets photographer keep safe distance from oncoming vehicle

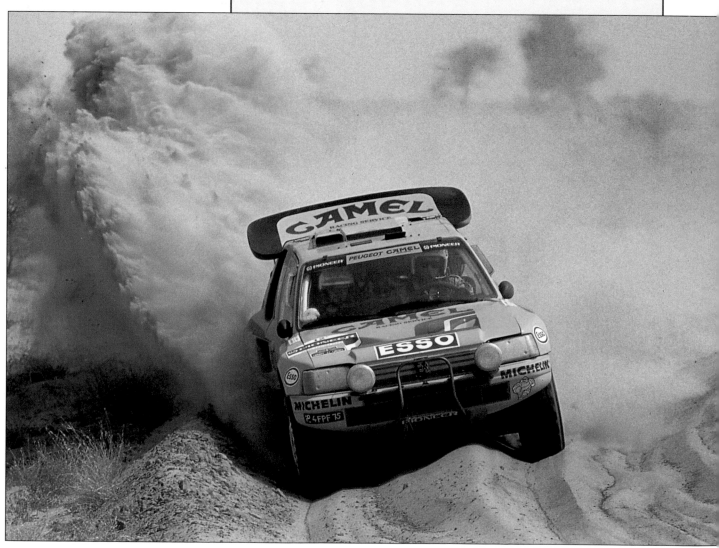

7 Pan the action

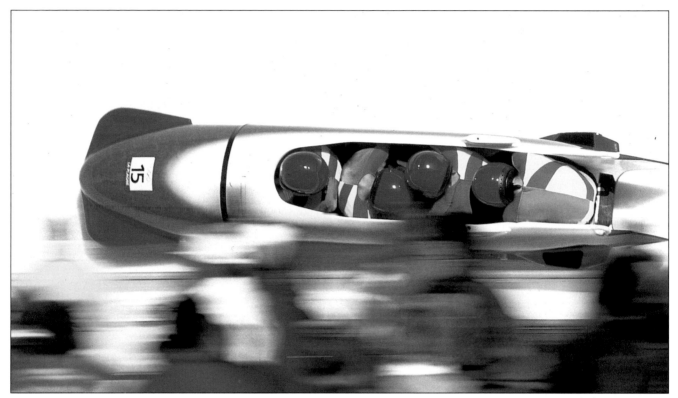

▲ BOBSLEIGH RUN
A sense of speed is conveyed here by panning the shot to blur the spectators while keeping the bobsleigh in focus. Notice how one team member is the wrong way round.

Convey a sense of speed by panning. This technique involves following a subject over a certain distance during the exposure. Select a position where the subject passes directly across the camera's field of view and turn your whole body from the waist as you track and shoot. The result should be a dramatic picture of a sharply defined subject against a blurred and streaked background.

Experiment with different shutter speeds. Best results are often obtained between 1/60th sec and 1/15th sec but obviously vary depending on the speed of the subject. Once you've released the shutter, make sure that you continue a smooth panning action. If you stop as soon as you've fired, the camera is likely to jerk and ruin the picture.

Most panning is done with the camera hand held but you can also use a monopod or tripod (a monopod is easier to use) coupled to a pan and tilt head.

8 Create a zoomed image

Change the focal length of a zoom lens during exposure to emphasize the impression of speed or to pep up a static scene such as a rugby scrum.

The resulting explosion of blurred colours and movement produces a very dynamic picture. Although you'll need a slow shutter speed of around 1/4 to 1/15th sec to give you time to operate the lens, don't worry about camera shake as this will be masked by the zoom effect.

When you are zooming, position the subject in the centre of the frame or just slightly off-centre, and select a background with a variety of colours for the best results.

▼ RUGBY ZOOM
Changing the focal length of a zoom during exposure injects energy and drama into this shot of a ruck.

9 Use blur

Deliberately blur the whole image to create an impressionistic shot. As with panning and zooming, choosing the right shutter speed comes down to experience and a little luck.

The appearance of blur is strongly connected to a subject's movement relative to the camera. A horse rider, for instance, riding directly across the angle of view may appear blurred at 1/250th sec. However, the same subject riding at the same speed towards the camera may be acceptably sharp even at 1/30th sec.

The results are hard to visualize beforehand, so it's best to take plenty of exposures and try out various different shutter speeds. When controlled blur succeeds, the exciting swirl of colour and movement makes a memorable and dynamic shot.

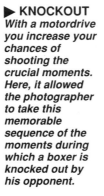

▲ **COLOURFUL CYCLISTS**
A relatively slow shutter speed of 1/30th sec used together with flash provided just enough blur to capture the jostling of these cyclists as they took part in a relay race.

10 Take lots of shots

Always take plenty of film with you. Luck as much as fast reactions determines success in sport and action photography. You'll probably have to take a considerable number of exposures before you come up with that special image which sums up all the exhilaration and spirit of the day.

A motordrive can be an invaluable asset as it gives the photographer a greater number of pictures to select from a particular sequence. Put the best ones together – say, the moments when a boxer is knocked out by his opponent – for a more powerful set of images than if you had chosen just one shot.

▶ **KNOCKOUT**
With a motordrive you increase your chances of shooting the crucial moments. Here, it allowed the photographer to take this memorable sequence of the moments during which a boxer is knocked out by his opponent.

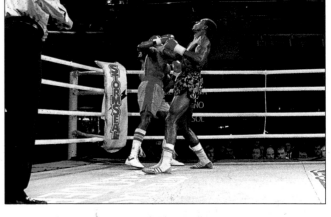

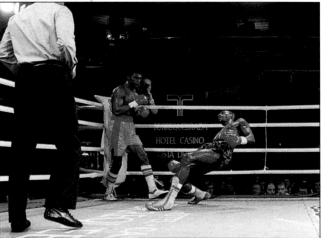

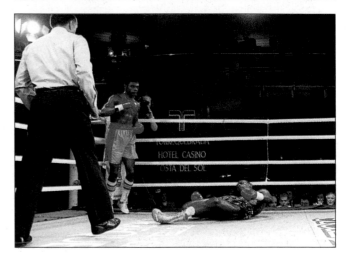

Dance

If you're interested in capturing human movement on film, dance offers the opportunity to portray the subtlest forms of physical expression.

From breakdancing to ballet, dance is a human activity which occurs in countless variations around the world. For the photographer, different kinds of dance require different approaches.

Classical ballet, for example, imposes particularly difficult working conditions because of the dim lighting under which it is usually performed. Often you will need a very fast film so that you can use a workable shutter speed.

To capture a sense of movement, whether indoors or outdoors, don't restrict yourself to conventional images. Experiment with slow shutter speeds and zooming to create a feeling of movement.

Use a telephoto lens to isolate a single dancer from a large group. Alternatively, frame your picture to include just a detail – for example, a ballet shoe or a colourful costume.

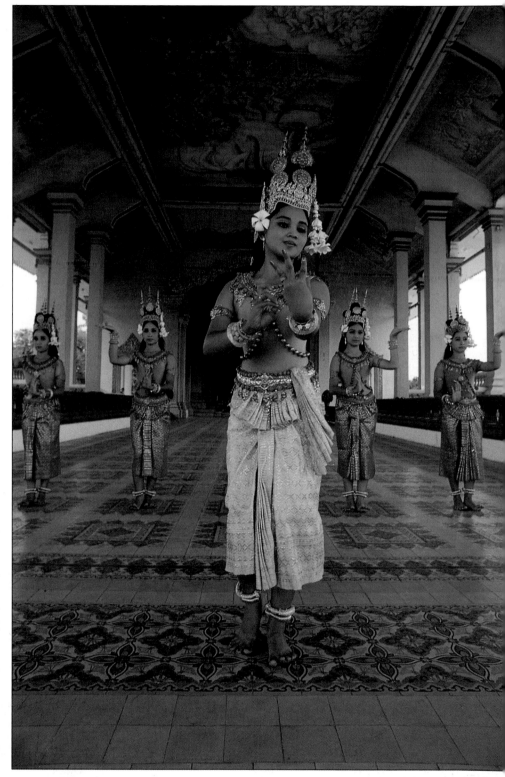

◀ STRAIGHT TO THE POINT
Photographing a detail can be just as effective as shooting the whole subject. Here the photographer used a low viewpoint to isolate the ballet shoes and legs of the dancer. These instantly recognizable images from the world of dance mean that the viewer has no difficulty imagining the elegant figure practising in a studio. Fast film, with its characteristic grainy quality, adds subtle texture and mood to this almost monochromatic image.

▲ CAMBODIAN DANCE
Traditional dancers with their colourful and elaborate costumes often make striking subjects. Here, Phnom Penh Palace in Cambodia provides an attractive setting for these dancers. The photographer chose a wide angle lens so that he could include all the dancers and obtain good depth of field. Working by available light meant shutter speeds were slow, so he asked the dancers to pose for the camera midway through one of their routines.

▲ KENYAN DRUM DANCE
Here the photographer chose to isolate one of the dancers for a less confusing image which captures the excitement and atmosphere of the occasion. Look out for bright colours and diagonal lines – both strongly suggest action. Here the splashes of colour and the diagonals of this Kenyan dancer's outstretched arms give a sense of vibrancy and rhythm to the picture.

▲ STREAM OF DANCERS
An overhead viewpoint and careful choice of shutter speed combine to make this unusual picture. A slow shutter speed records the graceful movements of a dance as an evocative blur. To be sure of success, try a range of shutter speeds and make sure the camera is steady, preferably by mounting it on a tripod. Here the colourful streamers lead your eye to the top of the picture.

▶ STUNNING SHAPES
Before trying to shoot modern, avant-garde dance, take the time to watch it, so that you have some grasp of the choreographer's intentions. Here, the photographer pinpointed the merging shapes of the dancers' bodies as an essential element of the performance. A plain background stressed this aspect. A splash of colour from gels on the lamps stops the shot looking too austere.

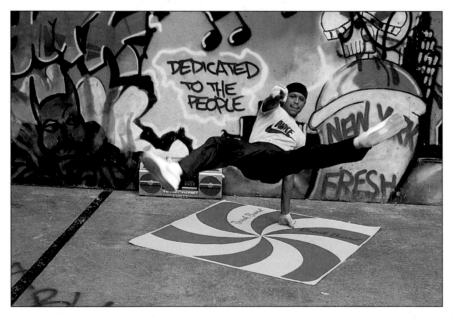

▲ BREAKDANCIN'
Modern urban life offers fascinating examples of street dancers, as in this photograph of a breakdancer in New York. A fast shutter speed caught the subject in mid-movement. The use of a wide angle lens captured the colourful wall in the background – an integral part of the picture which helps to set the scene.

Tip

Experiment

Dance offers you tremendous opportunities for creative photography. Don't stick to a single technique, but be bold and experiment. In particular, take advantage of camera controls that affect how the subject's movement is recorded on film. Vary your shutter speed, add flash or move the camera during exposure to echo the dancers' own actions.

▶ MORRIS MEN
Folk dancing often takes place out of doors, where onlookers may obscure the main subject. With careful planning, though, you can select a camera position that cuts out any clutter. In this picture, the photographer was careful to frame the shot to exclude the spectators.

▼ CLASSIC DANCE
Photography is rarely allowed at classical ballet performances, but you may find photo opportunities at rehearsals. Press calls are also surprisingly open, so don't be afraid to enquire at the stage door. Lighting at these occasions often simulates the final staging, so you must meter carefully to cope with the high contrasts caused by spotlighting. This picture uses the lighting difference as a compositional tool.

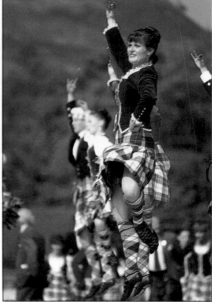

▲ CLOSING IN
The limited depth of field, caused by fitting a telephoto lens, makes the rich colours of this Scottish Highland dancer's costume stand out.

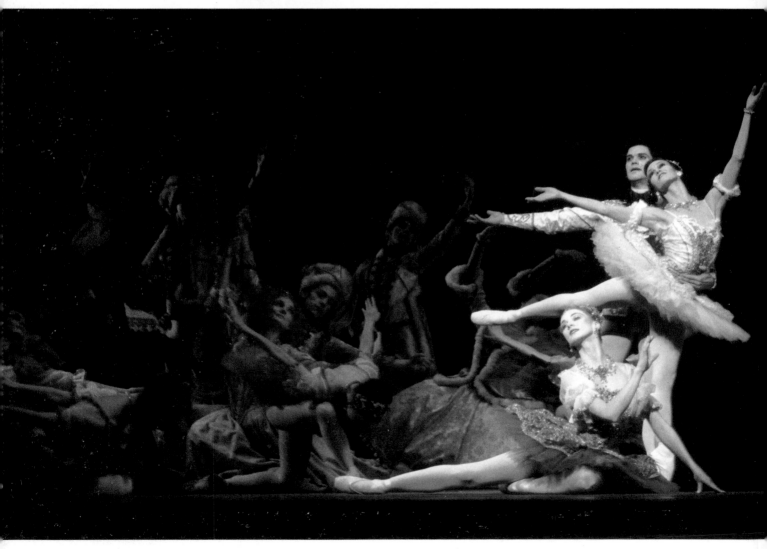